How to Create the Perfect Cut, Shape, Color, and Perm for Any Hair Type:

Secrets and Techniques from a Master Stylist

By Cosmo Easterly

How to Create the Perfect Cut, Shape, Color, and Perm for Any Hair Type: Secrets and Techniques from a Master Stylist

by Cosmo Easterly

Copyright © 2009 Cosmo Easterly. Published by Atlantic Publishing Group, Inc.
1405 SW 6th Avenue • Ocala, Florida 34471 • 800-814-1132 • 352-622-1875–Fax
Web site: www.atlantic-pub.com • E-mail: sales@atlantic-pub.com
SAN Number: 268-1250 • Member American Library Association

ISBN-13: 978-1-60138-402-7
Library of Congress Cataloging-in-Publication Data

Easterly, Cosmo, 1957-
 How to create the perfect cut, shape, color, and perm for any hair
type : secrets and techniques from a master hair stylist / by Cosmo
Easterly.
 p. cm.
 Includes bibliographical references and index.
 ISBN-13: 978-1-60138-402-7 (alk. paper)
 ISBN-10: 1-60138-402-5 (alk. paper)
 1. Hairdressing. I. Title.
 TT957.E227 2009
 646.7'24--dc22

 2008040252

 10 9 8 7 6 5 4 3 2
INTERIOR DESIGN: Meg Buchner • megadesn@mchsi.com
COVER DESIGN: Holly Marie Gibbs • hgibbs@atlantic-pub.com
ASSISTANT EDITOR: Angela Pham • apham@atlantic-pub.com

11-12-1292 BT

TABLE OF *contents*

\mathcal{P}reface 11

What You Will Find.. 11

My Process ... 12

Permanent Settings.. 12

Coloring.. 13

In Closing ... 13

\mathcal{C}hapter 1: All About Hair 15

Introduction .. 16

Hair ... 16

Creativity.. 17

Form and Creativity ... 18

Working With the Client.. 18

Reading Hair and Forming Hair 19

Understanding Details ... 20

Coloring One's Hair.. 20

Texture... 21

Shape and Balance ... 21

Conclusion ... 22

Chapter 2: Inducing Creative Growth 25

Introduction .. 26

Why the Beauty Industry? .. 27

Why Hair? ... 27

Make Something More Out of Hair Design 28

Things to Consider .. 29

Controlling Your Emotions .. 30

Feel Free and Fake it .. 30

You're in Control ... 31

The Clients .. 31

 Stance .. 31

 Clothing Style .. 32

 Mannerisms and Conversational Tone 32

The Experts ... 32

Chapter 3: Setting Goals 35

Introduction .. 36

Goals ... 36

Creating the Goal Outline ... 37

 An exercise .. 37

More About Goals .. 38

Your Talent ... 40

Setting Business Goals .. 40

The Conclusion About Goals 41

Chapter 4: Your Clients 43

Introduction ... 44

Tip: Don't Work For Tips ... 45

Selling Yourself ... 46

Keeping Clients ... 48

 Remaining Positive ... 49

 What the Client Wants 49

 Open Brainstorming .. 50

Questions to Ask Your Client 50

 A Reference .. 50

A Few Tips: Dealing With Customers 52

 Bad Customers .. 52

 Good Customers .. 54

Personal Tips: Rumors and Rubs 54

Conclusion ... 55

Chapter 5: Balance and Symmetry 59

Introduction ... 60

Balance Points .. 61

Psychology Tidbit about Balance 63

Another Part of Balance .. 63

Chapter 6: Permanent Waves 67

Introduction ... 68

An Introduction to Lotions ... 69

Introduction to Wrapping Tension 69

 Tension and Perming .. 71

 Tips to Tension .. 71

 Moisture with Wrapping .. 73

 How to Wrap With Tension 73

Introduction to Hair-Type Needs 73

 Fine Hair ... 73

 Medium Hair .. 74

 Coarse Hair .. 74

 Final Thoughts on Hair Density 74

Introduction to Perming and Coloring 75

 Same-Day Coloring ... 75

 Retouching ... 75

The Shampoo Bowl ... 76

 Drying the Hair .. 77

 Word of Warning .. 77

 Shampooing Final Thoughts 78

 How does this relate to
your daily life as a hairstylist? 78

How to Create a Permanent Wave 79

 Step 1: Prepare the Hair ... 79

Step 2: Pre-WRAPPING SOLUTION 80

Step 3: Analyze Hair Texture and Strength 80

STEP 4: TEST CURL .. 81

STEP 5: PERMING ... 81

STEP 6: Check THE SHAPE 81

STEP 7: RINSE .. 81

STEP 8: TOWEL-DRYING THE RODS 82

STEP 9: neutralize ... 82

STEP 10: REMOVING THE RODS And RINSE 82

A Few Techniques ... 83

Permanent Waves Summary 84

Helpful Tips to Remember 88

Chapter 7: Conclusion 89

Review Points ... 90

Creativity and Form 90

Perception .. 90

Goals ... 91

Clients ... 92

Hair Design Tips .. 93

Shampooing .. 93

Permanent waves ... 93

Final Thoughts ... 93

About the Author 95

Reference Section 97

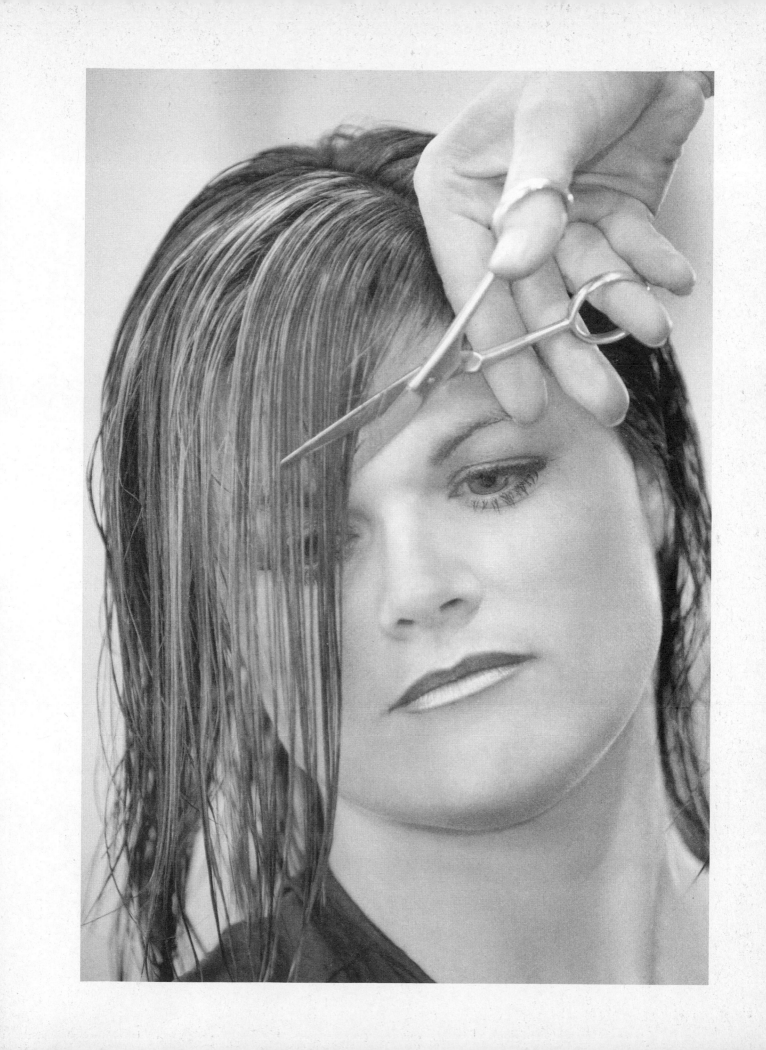

DEDICATIONS

God, for all your gifts, I give thanks, love, and light.

Thank you to my dear friends and family for always being there.

Thank you to the printing "MEGA" David Matchett for helping me get the book off the ground floor, as well as the Atlantic Publishing Company in Ocala, Florida, for their help and support.

To my parents, Robert and Loretta Easterly, for their belief in their son. To my Aunt Verna Lewis for helping me graduate.

To my children, for allowing me the time away to put this book together.

To Chad Easterly, Lauren Easterly, Clint Geer, and Lindsey Geer. May they all be inspired by hard work and efforts shown to them by my actions.

*To the staff at Planet Cosmo Salon (**www.PlanetCosmo.com**).*

Live well, God bless you, and thanks for visiting the planet.

As you grow, you see things from a new level. My desire is to assist the industry and grow to new heights professionally. It is important to grow for yourself and look deep into your intentions, as well as what is around you. As you plant your seeds in the garden of life, you want to make sure that you truly understand your plants. God needs all the plants, but you only need what works for you in your garden. If there are weeds, then you must take the time to look for yourself to find out why they are growing there instead of what you planted. Set your goals for the day and your path will be what you choose, not what someone told you. You are the key to your own life!

Live to inspire, inspire to live.
If it is to be, it is up to my committed action and me.

PREFACE

What You Will Find

The purpose of this book is to transform the working hairdress-er into a true hair artist, allowing them freedom of expression through permanent waving, cutting, and coloring hair. The goal is for students and professionals of all levels to gather new ideas and creativity. This book will provide you with the tools neces-sary to transform your client's hair into a masterpiece that they will be proud to show their friends (and, hopefully, that will get more clients for you).

The text is designed in such a way that everyone from the stu-dent to the experienced hair dresser will understand. It is a format designed to be used for the instructor or team leader to follow. The book is dedicated to the idea of ensuring that your own creativity in permanent waving, cutting, coloring, styling, and general hair design is truly tapped into, and that your goals as a hair artist are met. The technical aspect will cover all hair types and permanent waving concepts, color concepts, and cut-ting concepts to inspire creativity across the board.

The information has been broken up into specific segments for easy access. In some chapters, we will discuss theory as well as basic guidelines to follow while discussing key factors to successfully create any hairstyle. There will be key points for quick reference in case you run into a difficult situation, as well as quizzes to ensure that you are taking away all of the necessary material.

My Process

In determining techniques and learning exercises to be used in this book, I first surveyed the techniques used throughout the country. Then I spoke with individuals who have had perms, color, styles, and cuts, and tried to find out whether or not they were achieving their desired results.

What I found was that the end result seldom matched the desires of the client. There were a variety of reasons, not the least of which was that all permanent waves were wrapped in relatively the same way — color applied the same way, cuts the same, not making an effort to change, learn, or take classes. The end result is a hairstyle that many people have seen that has lost its originality and appeal. Most stylists pull hair up and cut it off like they learned in beauty school. So I chose to explore all of the popular techniques enjoyed by my clients, and I have gathered what I have learned here for you.

Permanent Settings

The concept of permanent setting came to me after I had personally seen the end results of a great deal of settings. After applying this to permanent waving, we came up with several effective and unique ways to set hair and achieve the client's desired results. How often do you set hair to see how it flows, such as with a round brush? How about using a flat iron to try to see how hair moves, either on base, off base, or half off?

Since then, we have begun teaching the idea of the permanent setting to others and have seen the concept achieve a great deal of success. This is what inspired me to write this book — to help the industry achieve successful end results in waving, cutting, and coloring, and hopefully see that same success achieved in other aspects of hair design.

Coloring

Coloring has become a large part of the hair industry — so much so that it has become a standard practice amongst hair stylists and clients. Hair color makes shapes look better, as well enhances how the eyes see the shape, so it has become an important addition to hair waving and styling and should be utilized appropriately. In this book, we will also discuss the ways that color can bring out the desired style and how it can enhance the artistic vision of you as the hair artist and what the client hopes to achieve with their hairstyle. The techniques included in this book are truly effective and will open your mind to your own ideas and color patterns. As you read this book, you will learn how to create art and paint like an artist so that the time spent in thought will always be worthwhile. One of these techniques I have spent 24 years perfecting; now, finally, we have the tools to share with everyone and get you started.

In Closing

My hope is that this book becomes more than simply a reference for hairstyling. I hope it inspires you to explore your own creativity and artistic passion, as well as teaches you how to achieve the desired results of both you and your client.

But above all else, I implore you to go out and see the world. The world is the source of all inspiration and art, and appreciating the world is the only true way that you will experience all that life — and God — has to offer.

If we live life to its fullest, then you can have a very effective life and impact others, inspiring them to live well, assist others, and be part of the world that serves.

Take the time to understand what God has created, from the spiritual to the wealthy; there is so much that can be learned and accomplished, and the more you do, the more your life will truly be at peace.

A NOTE FROM THE CEO OF THERMAFUSE

Cosmo and I first met over breakfast near his Planet Cosmo salon. A mutual friend shared that Cosmo was doing some very creative work in the salon, so I called and Cosmo graciously accepted an offer to meet that morning. In the years that have followed, it's become clear that Cosmo believes. He is very passionate about anything he does, and he lives out his beliefs by serving others.

This book is written with that same passion and servant attitude, and it contains a wealth of information that comes from decades of experience in the salon. I know it will be a valuable tool for any stylist.

Lastly, I'd like to say that it's a pleasure to call Cosmo my friend. He's an extremely positive guy with tons of energy and creativity.

Thank you for allowing me to be a part of this project and to share these thoughts.

Sincerely,

Van D. Stamey, CEO, ThermaFuse

ALL ABOUT *hair*

LEARNING OBJECTIVES

When reading this chapter, pay close attention to the following points:

- *Exploring creativity*

- *Finding the form*

- *Seeing what you want to see*

- *Let the light shine (color and accents)*

- *Does texture change?*

- *Why is shape so important?*

- *What is balance?*

Introduction

Since the dawn of time, people have cared about their appearance, even if they did not realize it. Throughout all of the early stages of man, new behaviors have evolved — designed to make people more attractive for mating and friend-making — through the invention of clothes to hide parts, the practice of bathing to remove smells and dirt, and the idea of tribal tattoos to mark people's status.

Hair, I should think, was one of the first things to be changed. Even if styling one's hair was no more than putting a leaf in it, hair is one of the few things that has always existed, will continue to exist, and that people cannot replace. They can style their hair, yes, but although their clothes can be changed or their jewelry swapped, their hair is always going to be theirs.

As a hairstylist, you are the one who is going to help people define their identity. As mentioned in Spider-Man, "With great power comes great responsibility." And, as their stylist, you are the one in charge of ensuring they receive the type of hair they want in order for them to feel confident and look perfect on a daily basis.

Considering that great responsibility, you would be surprised how many stylists simply don't know or think about hair. Sure, they understand that it is their medium, and they know when hair is damaged or healthy, straight or curly, and thick or thin, but they do not see hair as the important and interesting phenomenon that it is. In this chapter, we will discuss hair itself, so you can spend a little bit of time truly thinking about hair and using your thoughts in your work.

Hair

Everyone has hair, yet no one's hair is the same. It may have similar density, color, look, style, or feel, but at the root of all hair is a protein compound that is unique to the individual, just as the individual is a unique person in the world.

As such, styling one's hair involves a great deal of creativity because although you could style two people's hair exactly the same, the hair is inherently different because the people are different. What might reflect one individual's personality may not reflect another person's. And when they are viewed by the rest of the world, the style of their hair is what shows the population who they are. That is where your creativity comes in. You need to help understand the client and hair to the degree that you can create a work of art on their head that will get them viewed exactly as they want and expect to be viewed.

Creativity

For many, creativity can be a very frightening thing. You have learned a certain way to perform your craft, and going off on your own and using your own imagination can be a nerve-wracking and frustrating ordeal. And you are unlike the painter who, if they fail in their first try, can simply purchase a new canvas and start again.

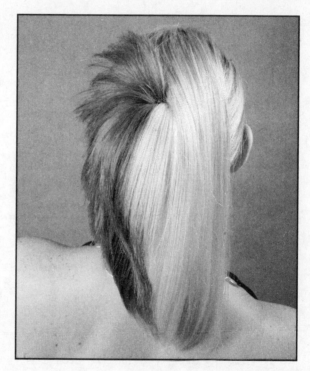

You, on the other hand, only have one shot. Mess up a single cut and you cannot get the hair — or the customer — back again. As such, most people do not take risks with hair, turning the individual's hair into the safest style they can create as to avoid any repercussions from making a mistake.

But you cannot be afraid to explore your own ideas. Your clients look to you to help turn their hair into a masterpiece, and it is your job to not disappoint. Your creativity and respect for hair is what got you into the profession, and if you truly expect to grow as a hair artist, you need to let yourself learn about hair and encourage your own imagination.

Form and Creativity

Form is everywhere. From the patterns on the back of a leaf to the silhouette of the mountain against a sunrise, patterns can be found in everything.

Hairstyling is an art form built around patterns. Every style is meant to have a distinct shape that makes it stand out from the pack. Whether it be wavy like a perm or round like a shaved head, all hair has some sort of design form; otherwise, it looks inconsistent to the eye.

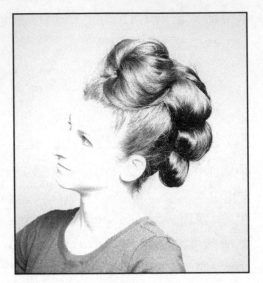

Remember, even abstract art has a form, even when that form is "no form." So too should every cut you make have a purpose, in order to create a final form that is pleasing to the eye.

To explore your creativity in form, you need to explore hair like one explores the world. When artists look for inspiration, the artists travel the world and see the forms in everything around them. They view the patterns in crashing waves of the sea or the lines created by a scurrying crab across the beach. They see the movement in the clouds or the tunnel of a cave, and they learn how their brush or pencil is going to create a form the way the world itself has created form.

Your hairstyling works the same way. The more you explore in the world of hair — and the world itself — the more you can bring that exploration into your work.

Working With the Client

Of course, the canvas does not ask for what is painted on it; the painter gets to decide. With hairstyling, however, the canvas is a person's hair, and that person has their own say in your work. Therefore, you need to learn how to

incorporate their needs with a vision — your vision. You need to listen to what they are saying and learn how to transform their form to match their desires as well as yours.

If your client decides they want more volume, for example, it is your job to recognize the form in their hair, analyze it, and adjust it in order to meet their desires. It is your job to listen both to what the client wants and what your hair is telling you. I call it *my* hair because I have the final say in what happens to it. I've watched stylists say, "Yes, we can do that," then they do the same cut as always, and the client still has no choice. Always give them a choice and see the different patterns, shapes, and forms that can enhance their appearance.

Reading Hair and Forming Hair

When I am looking at hair, I see the hair's movements. I analyze where it goes and what it wants to do, and listen to it when it tells me its problems and its desires. Clients know what they want, but they do not always know the hair. You are going to try to meet all of your client's needs, but you simply cannot start cutting until you have listened to what their hair is telling you.

In addition, when I decide I am ready to put form to the hair, I do not simply cut and hope that I create the look I am going for. I sit back, see the hair in its complete form, and then overlay that vision against what the hair is currently. That tells me what I need to change. If I see the form smaller in one end but the hair is currently long, I cut the hair to create the form in my vision.

In the art world, it is like drawing with a stencil, except rather than a stencil, you are seeing the vision in your head on the paper and drawing over it, even though there is nothing there. Once you can envision the final product before it has been completed, you will find that it will become much easier to make your vision into a reality.

Understanding Details

Though forming the final product is one thing, the design itself has its own measure of importance. There is such a thing as an ugly form, of course, as well as a form that is too generic. Therefore, the question is: What makes a great form?

The answer is "details."

Details are what help any style of hair design stand apart from the competition. It allows the hair to have its own unique flow, its own unique style and essence. Details are what make your hairstyle distinctive. If it were not for details, the client's hair may as well have been styled by a robot or a machine.

Details are there to help accent the form, help the form appear more unique, and help create a noticeable difference from person to person that makes the end result feel like their hair is their own, rather than a clump of dead proteins someone has placed on their head. Details are created using specific cuts, layers, movements, textures, shapes and, of course, color.

Coloring One's Hair

Which is more vibrant — the pencil sketch or the painted masterpiece? Clearly, color makes a difference; otherwise, there would be no reason for people to color their hair. Color as you would paint to give hair more detail in the form and accents. For example, accenting higher colors with lighter tones and lower points with darker tones helps the hair appear long, sleek, and elegant. It provides a direction for the eyes to wander, so that they can see the hair as it was meant to be viewed: from top to bottom. It is the difference between a canvas that is sitting right-side up and a canvas that is upside down. You do not want people to view the client's hair in a different direction than the way you envisioned it, so you use color to detail the hair and provide the direction of the canvas.

This is an example of how color helps create detail. Adding color has the potential to enhance the natural beauty of a particular piece of hair art, give it emotion, and even create a personality, just as it would for a painter.

We have worked on techniques for more than 24 years and can now share this part with you at our shows and in this book. Visit **www.PlanetCosmo.com** for dates and advanced education dates.

Texture

Every time you touch your hair, the texture of it is changing. Even something as inconspicuous as the weather has the ability to change your overall texture and look by changing the hair's direction, firmness, and moisture.

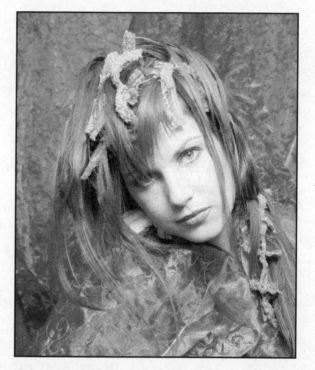

When you design hair, you want to keep these textural changes in mind. Is this individual going to be wearing their hair out in the rain every day? Are they going to be running in the rain every day? Do they live in the middle of the desert? Do you notice them constantly playing with their hair? Does their hair have damage from using no product? All of these textural changes need to be taken into account, and all of them can also be used to your advantage for creating a finalized product that is done to the exact specifications of your artistic vision and your client's needs.

Shape and Balance

The geometry of shapes is as important as its form. When discovering exactly how one wants to design someone's hair, it is this geometry that proves the overall look and balance on the person's head. If you and the client

decided you really like triangles, and you wanted to make a hairstyle in a triangular form, how would this look? The balance of the triangle, with one side significantly higher than the other, means a different look on all sides of the head. It is this balance and shape that make all styles unique, but it is also this balance and shape that ensures the final result looks good from every angle — all 360 degrees of the individual's head — in order to ensure you have created a great haircut.

Conclusion

As we begin to understand hair, we start to see how very little things affect the overall look and style of hair. The same can be said about life — over the course of your lifespan, it is not the big things that change who you are as a person, but all of the many little things that occurred that caused you to make friends, learn about yourself, or simply become who you are today. If all hairstyles were made alike, then everyone would look exactly the same, and all of our hair would reflect a complete lack of individuality.

Now, with hair, just like life, it is the little things that affect what makes it whole. From something as simple as texture, we get a long list of possible changes. What happens when it touches water? Is the individual going to style it? Will it look good if the person decides to put their hair behind their ear? All of these questions stem from just one little decision, and that is true of all hairstyles that you will ever create.

No matter how accomplished you become as a hair artist, don't forget how important these little things are to the overall look of the hair.

Chapter 1 REVIEW QUESTIONS

1. *Why should one be creative?*

2. *What is the importance of form?*

3. *What does viewing hair like a stencil do?*

4. *What affects texture?*

5. *Why is shape and balance important?*

Chapter 1 QUIZ

Fill in the blank:

1. A hairstylist is an artist and therefore must have
 _____.

2. Any style must look good from _____.

Answers:

1. *Creativity*

2. *360 degrees*

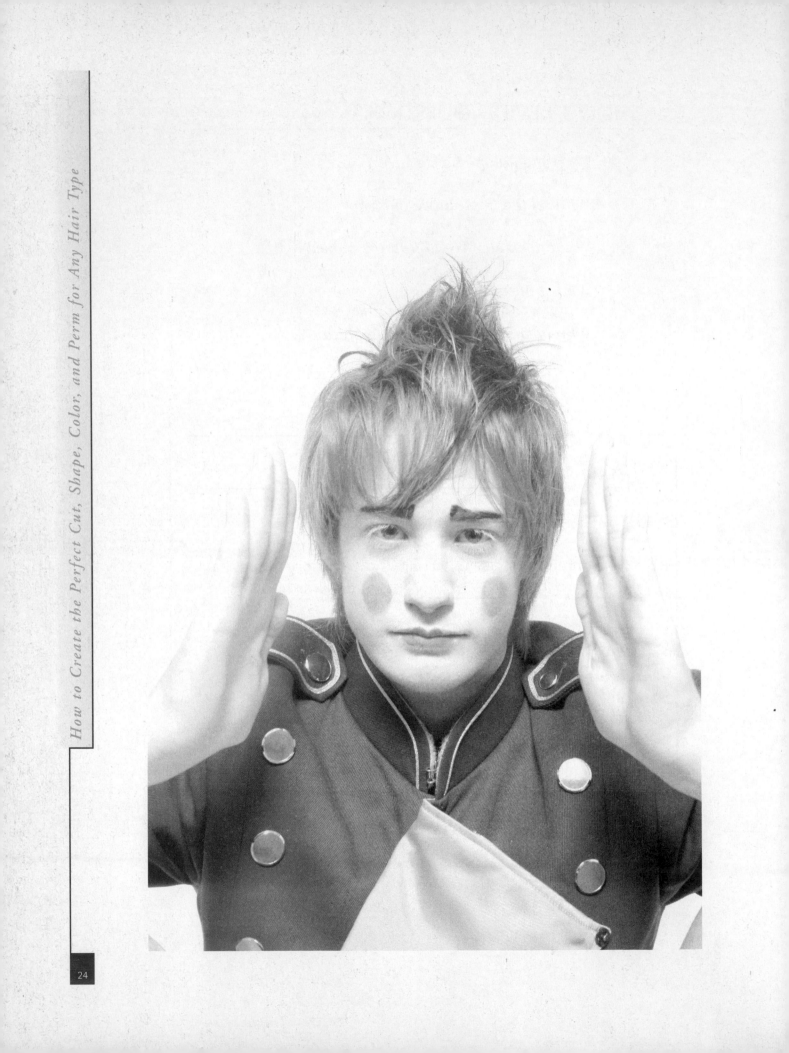

INDUCING CREATIVE *growth*

LEARNING OBJECTIVES

When reading this chapter, pay close attention to the following points:

- *Your own motivations*

- *The effect you have*

- *Controlling emotions*

- *Paying attention to the client*

- *The value of learning*

*I*ntroduction

So now we know why we need to encourage our own creativity and grow as artists. But knowing that is only half of the battle. To grow as a hair artist, we need to know more about ourselves and explore areas of our thinking that may not have been explored in the past.

Some of the questions to be answered are:

- Why did we choose to work in the beauty industry?

- Why did we choose hair design as our medium?

- How do you make something more out of hair design?

- How do emotions, clients, and experts affect your own hair design?

- Whom do you see when you look in the mirror?

When a client comes to the salon, they sit and wait knowing something is about to happen. They may be in somewhat of a hurry, or they may be getting a standard cut, but no matter what type of style they are going for, they know they are going to leave differently than how they came in.

In addition, however, they know that "differently" does not always equate to "better." Even the standard haircut for the standard male — the buzz cut on the sides and finger-length on the top — has the potential to be ruined by imperfect hands.

It is that which gives the client a feeling of both nervousness and excitement. The haircut has become an adventure, one that can end in success or tragedy, and has the ability to shape this individual's life for months. Therefore, when you come into the workplace ready to pick up your first pair of scissors for the day, it is important that you are primed and ready for the situation at hand through knowledge, awareness, and focus.

Why the Beauty Industry?

Everyone has different reasons for wanting to be a part of the beauty industry. For some, it was strictly a financial decision. For others, it was a lack of any viable alternative.

But for most people, there was something that attracted them to the beauty industry. Something that sparked a little bit of creativity and curiosity. Something that seemed appealing.

Although this question can only be answered by you, everyone has a reason, and this reason should never be forgotten when you continue down your career path. You chose to be working with beauty, and it is that reason that should both motivate and inspire to you be one of the best in the business.

Even if you are one of the few people that chose the beauty industry as a fallback rather than make a conscious decision, there still must be some reason that you chose your occupation. You could have gone into any industry — occupational therapy, the health industry, research, food services — but you chose beauty. There must have been something about it that made it special, and if you have never bothered to figure out what that special thing is, now is a great time to start.

Why Hair?

Another question that comes up is "Why hair?" Once you had chosen to work in the beauty industry, what is it that made you want to work with hair?

Was it because you enjoy hair itself? Perhaps you see hair as something you can use to create designs that make other people's lives better. Maybe you simply see the potential for hair design to be a fun, profitable industry. Whatever your reason, do not be afraid to think about it, focus on it, and even re-evaluate your reasoning in the future.

Many people get into hair design because they see hair as one of the truest and most natural forms of beauty. People can wear makeup, people can get plastic surgery, but hair is one of the few things you are born with that helps make you beautiful.

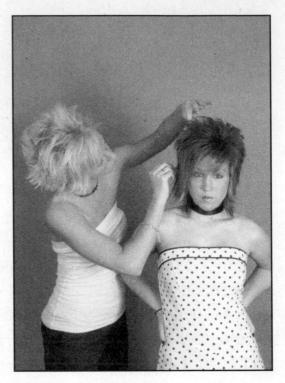

If you hope for hair to continue to be able to inspire you in the future so that you can continue working with hair throughout your life, you can never lose your passion for hair — and the only way to do that is to always remember what it is that first attracted you to hair design, and why it is so important to you.

Make Something More Out of Hair Design

Even those in the hair industry sometimes feel as though the work they put into every client's style is blasé and unremarkable. And in some ways this is an understandable reaction, because hair — no matter how perfectly styled — will grow back. While the painter can create a painting whose beauty withstands time, the hair art you have created, no matter how spectacular, is only going to be around for a few months at most before the hair has grown back full-force, and it is time to design the hair again.

But despite these understandable feelings, they are truly and utterly incorrect. The truth is that the work you create can be as influential as, if not more than, any painting.

When a painter paints his or her masterpiece, he or she does so on a canvas. That canvas does not benefit, and although people may feel their lives changed once they view a painting, most likely it has no effect on anything the person will ever accomplish, unless they happen to work as an art historian.

You, on the other hand, are changing someone's lives. Yes, it may be for only a few months, but as they come back to you for more styles, you are sending them out into the world different than they were before, every time. You are creating confidence; you are creating beauty; you are creating perception — and although you may believe the effects are not permanent, that is simply not the case. Photos will be taken (permanent); friends will be made, (permanent); people will be impressed (permanent); and confidence will be garnered (permanent). You are creating permanent changes using a temporary medium. You are making more of a difference than most painters ever will.

That is why if you expect to make something more out of hair, you need to realize the effect you truly have. You need to work with the difference you are about to make. Your goal, as the hair artist, is to positively manipulate the individual's life by adjusting his or her hair in the way that you expect will have the most positive effect.

As soon as you can grasp your own importance in the life of the individual whose needs you are serving, you will be able to become more than just a hairstylist; you will be able to alter someone's life for the better.

Things to Consider

In order for inspiration to take place, you need to understand what is in your control. Only by accepting those things you can change are you going to be able to use them in your favor. This includes keeping your emotions in check, believing in the clients, and taking the time to learn more from your craft.

Controlling Your Emotions

Much like any art form, the key is to be focused on your craft. An unfocused stylist is one who will miss the few key hairs that put a style over the top, or apply a bit too much tension as they remain tense throughout the ordeal.

So while it may seem like an unusual exercise at first, consider the importance of remaining positive, and try to find ways to stay happy while you work. What is it that makes you happy? Talking to your sweetheart? Going on a jog? Watching television? Whatever makes you happy, you should consider doing it before you start your work, because the goal is to make sure you have the focus and energy required to concentrate on your craft.

Similarly, make sure you learn to judge when you are simply not in a good mood. Your creative juices will be unable to flow if you cannot get the jump start to your day, and because you are the one who is expected to perform, you need to be sure that you are ready for the big day. Not only will your hairstyling abilities suffer if you feel yourself getting grumpy and distracted, but your client's faith in you will drop as well — and you will likely lose business, even with the best of haircuts.

Feel Free and Fake it

While it may sound illogical, faking happiness breeds real happiness. If you are feeling down, talk to your client for a while and act as though you are truly satisfied. There is psychology research that proves that if you act like a happy person, you will become happy. If you are not ready to begin because of a bad outing the night before, try holding down a positive conversation and see if you can get yourself in a better mood before you begin.

You're in Control

Remember, when cutting hair, you are in the driver's seat. Despite the desire to blame others for any problems you have while cutting hair, ultimately it is your responsibility to correctly do the hairstyle. There is no one else whom you can blame for your mistakes — not the person who upset you that morning or the night before, not your boss, not even financial stress, hormones, lack of sleep, or whatever else may affect you. It is always your responsibility to do the job right, and keeping yourself positive is the best way to maintain the level of brilliance your clients have come to expect.

The Clients

When exploring your own creativity, remember: All creativity starts with the clients. Without their permission, nothing can happen, and without their head shape, hair color, density, health, or youth, no true creative juices can flow. You cannot plan ahead for what your clients will want, nor can you picture an image of a certain hairstyle when you have not yet viewed the individual whose hair you are about to affect.

More about clients will be discussed in Chapter 4; however, there are certain visual cues you can and should be aware of from the client that will help spark your own creativity.

STANCE

Pay attention to the way this clients stand. Are they low and hunched over, possibly implying they are shy and insecure? Or are they standing up tall and proud, as though they are the alpha in the group of individuals? Because part of a good hairstyle is reading the individual's personality, you will want to pay attention to this feature in order to ensure you do not provide the shy individual with too blatant a hairstyle, just like you should not try to create too much subtlety in the hairstyle of the individual who likely is trying to command attention.

Note, however, that if it appears the shy individual may be shy because of their appearance, and it looks as though the hairstyle can change their confidence, this may be something you should consider.

CLOTHING STYLE

Clothes, like hair, are one of the few ways people are able to express their individuality on a daily basis. Though you should never assume the woman coming in a business suit wants her hair to look like something that belongs in an office (she may be coming from work or a job interview and prefer a hairstyle that is not reflective of her work dress), some clothing styles do give away the person's unique taste. Let your imagination go from there.

MANNERISMS AND CONVERSATIONAL TONE

The way the individual interacts with you can teach you a lot about whom they are as a person. If someone is incredibly interactive, with an abundant number of hand gestures and friendliness, you may be inspired to have their hair reflect it.

Again, the key is to look for any visual cues from the client to help create your own idea of what the client needs and can benefit from with a hairstyle. There are so many different possibilities, just as there are many different personalities, and no matter what you expect from the individual, you may be surprised. Thus, taking in anything you can learn from the few moments with the person before you begin to cut their hair is a great way to begin your creativity with the person's hair design.

The Experts

Finally, there is no harm in learning from the experts. People have cut hair before you, and people will cut hair after you. So if you want to inspire creativity in yourself and your hair design, learn.

For example, although books about haircut styles are designed for clients to help pick out a design (and not necessarily your own unique style or flavor), do not be afraid to look at them for inspiration. Perhaps someone in the past

did something unique with a curl or a color that catches your eye, and although you may not want to copy the same exact design, there may be other ways for you to utilize the individual differences.

The human brain may be an amazing place to imagine things, but it also cannot work with things it has not seen. Even the imagination works with things that have been seen by you in the past. Even if you go to sleep and dream about something as unique as a pink Gothic dinosaur with an attitude problem and 17 eyes, your brain is simply taking information it has seen in the past (the color pink, what dinosaurs generally look like, eyes) and putting it all together to complete the image.

By studying the hairstyles of many people who have come before you, you are helping improve what your brain can create, because you are providing it with more visual images it can manipulate to create a final picture.

The key is to never stop learning. Even studying the worst hairstyles imaginable has the potential to help you learn more yourself, and the time you dedicate to learning about your craft is never wasted.

Chapter 2 REVIEW QUESTIONS

1. *How do you have an effect on life?*

2. *What makes hair design differ from a painting?*

3. *What is your best emotion?*

4. *What are the three things to pay attention to from clients?*

5. *How does learning affect creativity?*

Chapter 2 QUIZ

Fill in the blank:

1. Hair design is a _____ change in a temporary medium.

2. The three things to pay attention to from clients are _____, _____ , and _____.

3. Looking at bad hairstyles negatively affects your own creativity. True or False?

Answers:

1. *Temporary*

2. *Clothing, mannerisms, balance points*

3. *False*

SETTING *goals*

LEARNING OBJECTIVES

When reading this chapter, pay close attention to the following points:

- *How does one create their own goals?*

- *Why are goals important?*

- *The exercise in goal creation*

- *The forest*

- *Your God-given talent*

- *More than just money*

- *The two reasons to care about goals*

Introduction

In the previous chapters, we discussed how creativity is one of the cornerstones of good hair design. We also talked about how hair is an art form, and if you want to truly be good at your craft, you need to fully understand all of the aspects of it.

But hair design is also a business. Even if you decided to take on hair design as an art form because you felt you could truly make a difference, it is still a job, and you are still trying to make money.

As such, one of the most important parts of the business process and one of the first you should take the time to do is create and set goals.

Goals

If you expect to succeed in the hair design industry, you need to take the steps necessary to achieve the end results.

Consider earlier, when you were thinking about what got you into hair design. What was it that made you get into hair? Your reason for wanting to get into the hair and beauty industry should always be a part of your goal. Perhaps you did it because you want to help the common man and woman achieve new levels of beauty and confidence. You will likely want to work in a local hair salon — a place where you can affect the average Jane or Joe who happens to need a good haircut.

Maybe you got into hair design because you want to create hair that makes an impression. In these instances, your goal may be to work at a more upscale salon catering to clients who are attending important functions. Maybe you want to possibly work in the film or theater industry, where your styles will have life on stage or in film.

Only by recognizing what your goals are in the industry can you have any hope of achieving them. And there is never a single goal. There are:

- *Short-term goals*

- *Medium-term goals*

- *Long-term goals*

And all three of these goals are important because you can never hope to achieve the long-term goals if you are unable to achieve the short-term goals in between.

In addition, having goals gives you something to strive for, and as long as you continue to focus on reaching those goals, you will never get tired of your work, as you will be seeing rewards for all the time you spend on your craft.

If you work hard to achieve your goals, you are no longer working, but applying passion and efforts to achieve your goals.

Creating the Goal Outline

If you have an overall long-term goal, you will want to fully understand each of the sub-goals that you need to reach to get there. To start, it is a good idea to begin brainstorming — sometimes there are goals you never realized motivated you in the past, or smaller goals that seemed less important compared to the larger goals, but are — in reality — equally worth achieving.

AN EXERCISE

- **List all of the goals you can come up with, even if you question whether they are goals you care about achieving.** Try to think outside the box because there are goals that may not seem related to hairstyling, but they may in fact be. For example, perhaps you are considering going back to school, even though you want to spend the

rest of your career as a hair designer; maybe you want to finish your degree for yourself, not for a job. Then, one of your goals will be to have a schedule that allows you to go back to school while still making the amount of money you need to support yourself.

- **Use the list to map out the order of the goals by achievability and importance.** To start, figure out your first step and how to achieve it. Then see what additional achievements can be based on that step or are logically next in line to be achieved.

- **Finally, once you have mapped out these goals, list the steps in days, weeks, months, and years, as well as when you expect to achieve each one along the way.** Be realistic and flexible. If one of the dates comes up and you have not achieved it, it does not reflect on you at all. I say this so you don't fall into a depression and let the small things get in the way of your goals. Remember, to apply actions to achieving a goal, you might have to give something up to make it happen. Also, if you have goals that you have given yourself a year for, remember that no goal can come too early, so try to achieve the goal as quickly as possible, even if you have given yourself plenty of time to complete it.

Once you have done all of this, you will have an outline you can refer to as you try to reach your goals in life. No one expects this paper to be set in stone, nor does anyone expect this to be the story of your life put down in outline form. People and their plans change over time, and you may want to change your own plans someday, regardless of what the sheet says. But by having a reference for yourself as to what you want to complete in life, you will have something to motivate you to achieve your goals in hairstyling and hair design.

More About Goals

Your life is like traveling through a forest. You continue to pass several trees, and while they may be similar, each tree is different. You may even see a tree that looks like something that will create an everlasting memory

— something you want to remember. But as you continue to make your way through the forest, if you look back, you may not see the tree behind you. Instead, you may see a new tree that looks similarly beautiful, giving you a different tree to remember in its place.

Goals work the same way. Like the forest, you may see a goal that looks appealing, something that you expect to achieve. But as you continue through life, you may look back at that goal and it may no longer be there. Instead, it may have been replaced by a different, more important goal.

The goals you want to accomplish with hair are always going to change. Whether they are going to change because new ideas have come to take their place, or because you realized that a different goal was more important than the others, they are still going to be constantly changing.

With hair, you should let your accomplishments help you decide where you want to go. Perhaps when doing a permanent wave, you become inspired — like I did — to make perms your focus, even though previously you liked the idea of working with all hairstyles. Or perhaps, over time, you realize you do not like the glamorous hairstylist lifestyle and would prefer to work in one of the smaller establishments in your local neighborhood.

Maybe instead of all of those things, you realize you like the business end of hair design more than you ever liked cutting hair, and you have decide you want to go into the business end of hair design by starting up your own salon and finding people with a specific expertise or clientele. Regardless of how you have come to the conclusions you have come to, you should never be afraid to change the goals in your life.

That does not mean you should change your goals on a whim. If it is something you have been working toward for most of your life, you are not going to want to change it at the last minute just because something new and exciting may have come into play.

But at the same time, limiting yourself to your own ideas simply because they were your original plans is bound to take some of the excitement out of life. There are so many things you can do with your hair design, and the more you allow yourself to be open to new ideas and new experiences, the

more you are going to be able to accomplish. Let that be a lesson you can take outside of hair design.

Your Talent

God gave you the talent to be a successful hair designer, and God wants you to use that talent to accomplish all your life's dreams. Hair design is an amazing, respectable, and — as we discussed in an earlier chapter — life-changing business. It is glamorous, has tremendous growth potential, and is a great way to enjoy what you do every day and put your skill into your craft.

Ignoring your talent is one of the biggest crimes you can commit as a hair artist. Giving up on your dreams and your goals is essentially giving up on your identity. Becoming a successful hair designer — or, if you are already a successful hair designer, giving up on your craft for no good reason — is essentially giving up on yourself. You have a skill and a passion for hair, or you wouldn't make it one day as a designer. Nurture your skills, experiences, creativity, and knowledge, and do not ever give up on your talent, even if you run into struggles.

Setting Business Goals

If you were to take two minutes and think about what your main goal as a stylist is, the first thing that will pop into your head is probably "to make money." But money is the easy answer, and it isn't going to make you completely happy. Think about other things similar to money that are equally important. Perhaps you want to be given a good amount of vacation time. Perhaps you would like full benefits or additional education. Maybe you want to learn something about yourself in a way you hadn't before.

Even money itself is not as simple as it sounds. How much do you want to make? How many hours and days are you willing to work to make that money? How many hours and days are you willing to work to achieve your goals, and how much does money have to correlate with that?

Finally, how would you like to make that money?

These things are important because they have many subtleties that may need to be planned out. They may all not be goals per se, but they are plans that help you achieve what you want. For example, consider that the average tip is about 15 percent. If you decide you want to make a little bit of extra money, perhaps you are good at coloring or perming and can complete the job quickly and efficiently. In these cases, you would try to learn to specialize in these areas as well as find clients in these areas, because the better you are at a specific part of your craft, the faster you can complete it — and the happier your clients, the bigger the tips, and the more money you will make over time.

Learning something like permanent waving to the point where you have become an expert is one way that you are going to be able to meet your goals as a hair designer and improve the monetary flow without having to increase your hours, or find yourself higher in the ranks at your work.

The Conclusion About Goals

Goals are malleable and can change at a moment's notice. So what is their purpose?

The purpose of goals is twofold. First, goals give you something to strive for. The more you wish to accomplish in your life, the more likely you are going to stay motivated and ultimately accomplish it. Even if these goals change, you will never lose your motivation, provided you are willing to work toward achieving what you have set forth to achieve. It is never perfect and it is sometimes difficult to reach every goal you have set for yourself, but setting goals is important nonetheless as a way to ensure you are able to improve your life and keep the excitement and growth in your craft.

The second reason is truly for you. Mapping out your goals helps you keep a hold of your life. Hair design can be a stressful and complicated business. There are clients and customers to remember; there are days and weeks to plan; there are names to try not to forget; and a wide variety of hairstyles that involve you trying to transform your creativity onto one individual's hair well enough that they leave satisfied, but fast enough that you can complete the task, make your tips, and leave for the day knowing that you have made the money you need or want to make. With so much hectic energy in your

life, taking the time to reflect on paper what your overall goals are and how you hope to achieve them is a good way of not only re-evaluating what you have accomplished with hair design, but what you have accomplished in life as well.

Chapter 3 REVIEW QUESTIONS

1. Why should you care about short-term goals?

2. What is a goal?

3. Why is "money" not a complete answer?

Chapter 3 QUIZ

Fill in the blank:

1. Most people's first goal that comes to mind is _____.

2. When something seems exciting, changing your goals immediately is acceptable.

3. When something seems exciting, changing your goals after you have carefully considered whether or not this is a new goal or simply a passing fancy is acceptable.

Answers:

1. *Money*

2. *False*

3. *True*

CHAPTER 4

YOUR *clients*

LEARNING OBJECTIVES

When reading this chapter, pay close attention to the following points:

- *The tip of tips*

- *The importance of selling yourself*

- *How to keep clients*

- *The benefits of open discussion, questions, and dialogue*

- *How to deal with bad customers*

- *Final thoughts on pleasing the customer and its limits*

*I*ntroduction

For a while now, we have discussed what it means to be creative, how to bring out that creativity, and how to set goals for yourself in order to achieve what you hope to achieve from hair design and from your business.

Now it is time to discuss the one detail that makes all of this possible, and the one aspect that you need to most focus on if you expect to succeed at your job: the clients.

If you have ever worked for a dead-end job in the past, then you surely realize there are many bad clients and customers, just as there are many good clients and customers. It doesn't matter where you work or how perfect you are at your job; someone is bound to come in and treat you poorly. That is the nature of life.

But how you handle clients is the difference between being a wealthy hair designer and being a starving hair artist, unable to find a job. You need to find and hold onto clients, appease bad clients, and make sure the good clients you have don't get taken for granted. You also need to know, meet, and understand clients before cutting their hair so you can be sure that whatever design or style you are choosing is going to turn out wonderfully for both you and your client.

As you can see, your client is one of the most, if not the most, important parts of hair design. In this chapter, we will go over all the traits that make a client important, how to talk to a client, and even what questions to ask to ensure you are about to style their hair properly.

Always do a consultation every time they come in. If you work for your clients and offer them new and exciting things, they will realize you're a truly professional hairdresser. Try to talk to them about trends and new things, offering products that will help them. I hear clients say they have had the same hairstyle for years — and it is the hairdresser's fault for not offering new ideas.

Tip: Don't Work For Tips

Before we begin any exploration of the client's needs and wants, the first advice I can give is that no matter what you do, don't work for tips. Tips are the death of many good relationships and can be an end to your business and a possible chance at success. Don't expect, and you won't be disappointed.

That is not to say tips are not important; they are, and they are the primary way most hair designers make their money for daily life. The key is to not work for them — that is, don't focus so much on getting and improving your tips, nor should you assume that just because someone did or did not tip you, it somehow reflects their kindness as a client. Always remember MFE: money, fun, and excitement. If you are excited about life, and you have fun doing your job, the money will come. Focus on the experience, not the finances.

Perhaps you have a client whom you have taken on for the first time. You give them an amazing hairstyle; they love it, and you love it. The total is $97.50 dollars, and the entire procedure took you more than an hour and a half. Now it is time for them to pay, and they only give the cashier $100 and leave.

When you work for tips, the natural reaction here is anger. Why didn't they tip you more? Was the haircut inadequate? Are they simply cheap? Are they just mean?

And the next time the client comes in, you may treat them just a little more rudely or a little more spitefully, and again, they only tip you $2.50. You would not enjoy the experience.

Now, it is possible that the individual may be cheap. It is also possible, however, that the first time the client tipped that little was because they only had $100 on hand and were unable to make the tip they wanted to give you. Then, the second time they came in, your rudeness to them is what caused them to tip less. You lost money on the tip because of your own focus on caring only about how much money you made — not on the client and the hair. It is impossible to know the situation your clients are currently in just by judging their tips.

And what if the client is cheap? What if they simply do not tip a lot?

Well, if you did your best on their hairstyle, and continue to do your best every time they come in, then they are likely to tell others what an amazing job you did; you will get more clients, possibly even better clients, and eventually get the tips you deserve. At that point, if necessary, you can simply phase out the client who tips you poorly, or continue to help them because you are the hair designer — and they are putting their trust in you.

Similarly, just because someone tips well does not mean they are suddenly going to be better. Perhaps they tipped you $10 extra one day simply because they felt happy and generous. They are not necessarily going to do that every time, and expecting these high tips from them is only going to leave you bitter and disappointed. It is also likely that they are going to catch on to your sucking up and be less willing to pay you as much.

Whatever happens, even if your goal is to make more money, never work directly for tips. As with any artist, you should always do your best; never sell out your craft for more money. If you do, you are likely to make less over time, alienate more customers, and overall become a worse hair designer than you would have been if you had stuck to it.

Selling Yourself

With that out of the way, it is time to talk about finding clients. Finding clients is itself a skill that tends to be under-appreciated in the hair design field. In a way, you are trying to pitch your services to anyone who may come your way — whether it is through offering them a business card, or treating them like a king or queen in order to impress them.

You may not have gotten into hair design to be a salesman, but learning exactly how to be a salesman is still one of the most important parts of earning clients.

It is like pitching your script for a Hollywood movie, except you are the script. You are trying to convince the director (of the hairstyle, a.k.a. the client) that your work is on the upper tier of hairstyle and hair design, and that they should be honored to pay you for it.

Generally, selling yourself can be broken down into these three parts:

- ***Knowing your subject***

- ***Researching your theory***

- ***Being positive***

With knowing your subject, a large part of that is your ability to both be perceptive and withhold perception. While those may seem like contrasting ideas, the goal is to be able to go to your client, try to understand them, get to know them, and try to make judgments about them — but never, ever assume that you are correct. Always be open for them to break free from the scheme you had created for them.

If you don't, you are unlikely to be in sync with your client, and you may possibly lose their business. Bad hair designers don't pay attention to their clients at all. And good hair designers are perceptive and gauge their client's wants and needs. But great hair designers are also open to the client being different than what they expect, and they do not assume their perceptions are correct. The good hair designer is likely to still be right the majority of the time, but the great hair designer is going to be far and away more effective at their craft.

Researching your theory is not quite as simple. Once you have made the judgment of the client, and you believe that you know enough about them to try to make a call on what type of hair design they will like, what next? How do you know which hairstyle to use in order for it to be the most effective it can be and make the most positive impact?

For this, you need to continue to teach yourself about modern styles and about what people like to see in hair. This may be as easy as walking along

the crowded streets and seeing what people are doing, or as difficult as actually surveying and researching individual practices to find out what is most preferred. Whatever you decide to do, the goal is to keep yourself informed so that when you have gotten to know your subject you can make the call on what they want that will convince them you are the hair designer for them.

Finally, always be upbeat, positive, and energetic. We have likely all come across the annoying salesman in the clothing store who will not leave us alone and continues to try to sell us a jacket we do not want. And so for many hairstylists, they believe they should refrain from being happy and bubbly, so as not to irritate potential clients.

But with hair design, you know they want you. They will always need and want their haircut, and the key is that you are showing them you are a willing, adventurous, energetic, and skilled hair designer. You are selling them on the idea that when they decide to put their hair in your hands, they are putting it in the hands of an individual who wants to be doing what they are doing, and is ready to cut their hair in a manner that is beneficial for them.

All three of these are important if you expect to sell yourself to any potential client, and keeping to them will not only help you earn more clients, but also increase client retention as time goes on.

Keeping Clients

Ask yourself one question: When you are cutting and styling the hair, what are you thinking about? Are you thinking only about the end result?

Many hairdressers seem to have forgotten about the clients, and how the clients have feelings, too. Haircutting is not a one-person endeavor. Even if, in your mind, you have managed to create the most perfect style — one that will help earn your client respect, love, money, and fame — if you completely ignore the wants and needs of your client, or if you simply completely ignore the client as a person, your client retention, tip, and business will suffer.

The clients are people, and as such, many of them do not want to simply sit in a chair for two hours, completely immobile, as though they were a

machine getting an oil change. They want to be seen as a human being and spoken to so that they are given some sort of respect.

Are there going to be many clients who would prefer you not to speak to them so that they can simply get the job done as quickly as possible and get out of the chair? Of course. But this should be obvious from the way they speak back to you; simply assuming they don't want to talk is one of the most harmful mistakes made in a client/customer relationship. Even if you have had the client for a long time, and the client has never once made any effort to speak to you in a friendly manner, always ask a few questions. Who knows? They may have been going through a rough time and are finally ready to be friendly to the hairdresser they have been using for a long time.

REMAINING POSITIVE

This cannot be emphasized enough, so it will be repeated again here. Do not take your personal life issues out on your client. If you are going through a difficult time, keep that at home or in the break room. Once you are out on the floor cutting hair, remain positive, even if you have to fake it.

This includes not "ranking" on past customers of the day. Complaining about how a client acted or whining over a lack of a tip even though the hairstyle was perfect is only going to make the client uncomfortable. Similarly, most clients are not a great deal interested in what is going on in your life, so only get into that discussion if the client asks. Always keep talk about yourself to a minimum and questions about the customer at a maximum, unless you know for a fact that the client you have is interested in hearing about you.

WHAT THE CLIENT WANTS

Fashion is important, but what the client wants always outweighs the current trends. No matter how much you want to style someone's hair a certain way, or disagree with their preference on how to style it, chances are you are only going to make the client upset or uncomfortable if you continue to disagree.

While most clients are open to suggestion, keep that suggestion open-ended, and never make it sound like you are forcing your will on the cli-

ent. Despite your artistic vision, a happy client is better than an unhappy client, and it means more to the client that you listen to what they want than your keeping them up to date with fashion trends. And it means more to your wallet, as well.

OPEN BRAINSTORMING

Although you need to always go with what the client wants the most, that does not mean a client will not appreciate your taking the time to brainstorm ideas for their hairstyles.

When a client first sits down, I like to push their hair around when it is dry in order to check out what looks best. Using dry hair helps with my own idea process, but it also shows what the hair may look like to the client. When you show the client the shape ideas you have for it and how you expect to get there, you are helping them both relax with your expertise and receive a hairstyle that is more likely to be a fashion trend and original than anything the client will come up with themselves.

Questions to Ask Your Client

A REFERENCE

As discussed earlier, open dialogue with your client increases client retention. But there are also important questions for helping you to figure out how you are going to style this individual's hair, as well as to how you can keep conversation business-oriented in order to gauge how much they want to talk on that particular day.

But remembering to ask all of the important hair design questions — or any questions at all, for that matter — can be difficult. So here is a list of things to ask your client to ensure you can learn enough about your client to give them the style they want, as well as engage them in enough conversation that they feel as though they are treated with respect:

15 THINGS TO ASK YOUR CLIENT

1. How much time do you spend on your hair in the morning?

2. Do you use a round brush?

3. Do you towel-dry your hair before blow-drying it?

4. Do you use a diffuser?

5. Do you use gel or mousse in your hair before you begin to style it?

6. How do you apply your styling product?

7. What problems are you having with your hair?

8. Have you ever had a perm?

9. What types of problems have you had with a perm?

10. Are you on any medications for your hair, or on any that would affect your hair's health?

11. Do you use a curling iron?

12. Do you use a straightener?

13. Do you style your hair with rollers? Hot or cold?

14. Do you style your hair every morning?

15. How often do you get your haircut or styled?

These 15 question should cover everything you need to know before you begin styling their hair, and also give you enough of an opportunity to talk to the clients to keep them assured that you care about them, as well as to figure out whether they are the type of people who want to continue with friendly conversation. You will be seen as an expert by your clientele, and you are far more likely to retain them.

A Few Tips: Dealing With Customers

Most clients are simply clients. They schedule their appointments; they treat you with respect; they finish their hairstyles; they tip fine; and they move on. Though they may be enjoyable people and good business, they are generally unremarkable and tend to not leave that much of an impact on your work and personal life. Be careful not to forget them, and they won't forget you.

But extremely good and extremely bad customers are different. They are far more noticeable, leave much more of an impression, and need to be dealt with the utmost care if you expect to make it as a successful hairstylist. Here are a few tips for dealing with good and bad customers so that you can keep your emotions in check and your skills honed.

BAD CUSTOMERS

Bad clients are every hairdresser's worst nightmare. They are rude, difficult, consistently incorrect while assuming they have some expertise they clearly do not have, and rarely tip enough to matter. They may even bad-mouth you publicly — or worse.

Dealing with just one of these types can be devastating and can throw a hairdresser off his or her game for days or even weeks, depending on the degree of poor behavior.

There are two factors you have to remember about bad clients:

1. Although only a small percentage of this world consists of bad people, they do exist, and you may have happened upon one in your chair. It does not reflect on the rest of the population.

2. Not everyone can be happy with their hairstyle, even when it is both artistically and fashionably perfect, and conforms to everything the client asked for, to the letter. Even after that much success, it is possible for the client to still be upset, because perhaps their image of themselves is far different than the image they actually portray.

Regardless, in both of these instances, you need to learn from what happened — then completely ignore it. If you dealt with a genuinely bad person, then who cares what they think? They're bad people, and bad people do not deserve the type of respect they inherently receive by your caring about their rudeness.

But still try to learn from what happened. Perhaps you did make a mistake, or maybe there was something you can learn from the final hairstyle that would have led the individual to be disappointed. Once you find out what it was, however, it is still time to forget about that client and move onto the next one. The longer you let the problem lull around in your brain, the more it will affect your work, leading to more bad clients.

If you are looking for a way to deal with struggles you may be facing, there are a few suggestions.

First, if the client was outwardly rude in front of your next client, there is no harm in asking the next client if you can take a break for five minutes to cool down, provided that when you come back, you do not talk about the last client and stay warm and positive throughout the hairstyling.

Second, if you refrain from getting snappy and are able to maintain your cool, shrug it off and finish the job; when it is over, you can forget it ever happened.

And finally, if the client is being rude to you, feel free to respond with completely fake positivity. That really throws off bad clients, and it will help you feel better, so it is a win-win.

GOOD CUSTOMERS

Now, you may be asking yourself: Why would you need to learn to deal with a good customer? But the reason is that good customers are far too often taken for granted, just because they are good.

The problem is that the hairdresser begins to assume they are going to be a good customer and either:

- Does not make the same effort they normally make in order to ensure the client is enjoying their time.

- Makes too much effort because they expect if they act even more positive, the good customer will become even better.

In both of these instances, you are bound to make the clients not enjoy their stay and create an unpleasant atmosphere for both you and your good clients, harming their relationship and increasing the chances that they will go elsewhere for their next appointment.

Continue to be your positive self. Ask the clients questions, gauge them, and engage them as though they are new clients whom you happen to know a lot about, because you want to be sure that they stay happy and continue to like coming to you for the same reasons they liked coming to you previously.

Personal Tips: Rumors and Rubs

As a final detail to discuss in this section, I'd like to take a moment to talk about rumors.

After you have been seeing your client for long enough, you and your client will be tempted to feel like family — a group of people who are open to discussion, and with whom you can discuss anything you want. One of the items of discussion so often brought up is rumors.

We are here to pamper and serve our clients. We want the clients to be happy, and if the clients are happy, then we know that as a business, we are happy, too. This pampering may even involve neck and hand rubs while we talk to clients, listen to their opinions, or wait for their hair to dry. It involves

doing whatever we can — within reason — to ensure that when the client goes home, he or she is truly satisfied with the experience.

But we tend to avoid the spreading of rumors. Rumors may be interesting, and they may be fun, but they also have the potential to blow up in our faces. A rumor can be misheard, mistaken, or misunderstood, and when we bring rumors into our workplace, we know we are risking a lot in terms of client happiness.

As general advice, if you expect client retention to stay high, it is best to avoid the spreading of rumors so you can be sure that you never accidentally offend someone — and ensure that nothing clse comes back to bite you.

Conclusion

As you can see, the client truly is the most important part of hairstyling and hair design. Clients have thoughts, needs, opinions, and personalities of their own, and although we may like to judge them for a specific action, flaw, or behavior, it is far more beneficial to realize they are in control and that they are at the heart of your business. If not, then you are simply a diaper store that doesn't appreciate babies, or a hotel that dislikes tourists.

That is why it is necessary to treat all customers like equals: All customers, even bad customers, are the reason this field exists. While it may seem like poor-tipping, difficult customers are something to get rid of, they are also what helps

keep the industry alive, because without their market, the world would need fewer hairstylists and — ultimately — less of you.

So go out and talk to clients. Try to bond with them; try to make them feel as important as they are. It will be good for your own business because all clients are there to help you build a client list; it will be good for the entire beauty industry, as continuing to serve all customers helps to make sure that all of us have jobs; and it is good for the world because no matter what you may think, your hairstyle is still somehow making a difference on the planet.

While we move into the sections about some of the basic procedures in hair design, it is important to remember that all of our work lives, dies, succeeds, and fails by the client, and that it is the client who ultimately gets to decide whether they approved of and enjoyed the hairstyle.

Chapter 4 REVIEW QUESTIONS

1. *Why is it important not to work only for tips?*

2. *How do you sell yourself to clients?*

3. *How do you maintain the clients you have?*

4. *How do you deal with good clients?*

5. *How do you deal with bad clients?*

Chapter 4 QUIZ

Fill in the blank:

1. Despite its importance, never work for _____.

2. It is beneficial to keep all of your clients, even your bad ones, especially when you are just starting to build your client list. True or False?

3) Good clients are easier to maintain than bad clients. True or False?

4) In order to gauge whether or not the client wants to talk to you, it is a good idea to start out by asking him or her hair-related _____.

Answers:

1. *Tips* 2. *True*

3. *False* 4. *Questions*

BALANCE AND *symmetry*

LEARNING OBJECTIVES

When reading this chapter, pay close attention to the following points:

- *What a balance point is*

- *Even vs. odd balance points*

- *The psychology of symmetry*

Introduction

You have likely already learned about how to do hair, or you are in the process of your discovery, so we will not bore you with a long list of standard procedures in the haircutting industry.

As you have noticed throughout this book, we are not discussing the basic procedures of hair. To truly learn how to deal with hair — or at least the technical aspect of hair design — you are most likely to benefit from a class on the subject that gives you hands-on experience cutting hair.

No, what this book has been about and will continue to be about, even as we go into discussing a few tips and tricks from the industry, is that you may be fine with hairstyling if you learn all the techniques of hair design — but it is not until you can transform your imagination outside the box that you will become a great hairstylist.

If your goal was to just be "good," there would be no reason to read a book like this or, for that matter, any book that talks about hair. You can be good simply by being sure-handed, which is a skill even those outside of the hair industry can have. But to be truly great — to be a master of hair design and a master of the hairstyling field — you need to be willing to transform your mind around your craft and ensure that everything you do — every action you take and everything you learn — is designed to improve your ability to work with people's hair.

If it were easy, everyone would do it, and everyone would be good at it. But it clearly is not; otherwise, this book and all lessons like it would be counter-productive. So even as we start to talk about some of the technical aspects of haircutting and hair design, and when we go into the next chapter that will (finally) be about how to create the correct permanent wave, we are still going to discuss some of the more existential parts of hairstyling and hair design so we can continue to expand your mind around the craft and keep your brain active in the hair industry.

You can never learn too much. So it is with that in mind that we, the experienced hair designers, will continue to teach you about the different tools and tricks you can use to expand your abilities.

The hope is that someday, you too will become an experienced hair designer who is a master of the field, and be able to pass on the information like a professor in the classroom with an expertise that is unmatched by any everyday hair designer. No matter how old you are or how long you have been working in the beauty industry, you are still the future of hair design, and all knowledge and ability depends on you.

\mathcal{B}alance Points

Balance points are the visual cues. Balance points ensure the hair will look even or balanced on both sides of the face from different angles. Balance points help the hair designer make sure the hairstyle they are creating doesn't have an inherent awkwardness to it that causes the style to lose a great deal of its "oomph."

Balance points are one of the keys to making sure everyone is pleased and satisfied with the hairstyle, from you, to the client, to everyone who will encounter the client in the future. When the hairstyle has achieved good balance, it will continue to look good from all angles, resulting in a significantly better hair design and a more effective haircut.

If the hairstyle is off-balance, it does not really matter how good the hairstyle looks to you — the client and everyone who sees the client will dislike it, even if they do not know why.

One of the interesting things about balance points is that it is not always seen in the face shape or the shape of the head; it is generally seen in the eyes, nose, and lips. If you look at a person's face, you can determine by the eyes, nose, and lips whether the person's balance points are odd or even. It general works as follows:

- **Even** = Round eyes, round nose, round lips

- **Odd** = Almond eyes, odd-pointed nose, odd and angular lips

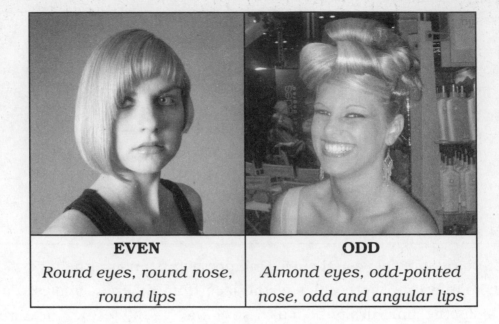

EVEN	ODD
Round eyes, round nose, round lips	*Almond eyes, odd-pointed nose, odd and angular lips*

In general, majority wins, so if the individual has almond eyes but a round nose and round lips, those faces are generally even, and if the person has a round nose with almond eyes and odd angular lips, that person is going to be considered odd-balanced.

To start judging this visually, cut the face in half and compare. Start where the ear connects to the head (consider this the 0 point), and move in 2-inch increments, thus making all numbers even. Odd begins 1 inch down from where the ear connects with the head, and moving in 2-inch increments.

Or, if you are struggling to understand this, simply look at your face in the mirror; stick your head straight forward and notice whether any of the pieces of your face are uneven. This includes ears as well, as many people have uneven ears but a relatively even head.

It is very, very important to check out these balance points before starting the hairstyle, because poorly balanced hair can ruin even the best hairstyle. Assume that the ears are uneven, for example. Let's say you are cutting hair on a male and you want to use the ears for distinguishing where to cut the sideburns. If you do not check to see if the ears are unbalanced, and you cut the hair according to where the hair meets a certain part of the ear, you are going to have significantly uneven sideburns, which take away from the balance and effectiveness of the hairstyle. Had you simply checked first and

seen that the individual's head was off-balance, you would have noticed very easily and been able to cut the sideburns in such a way that the hairstyle did not appear like it was chopped together, resulting in a significantly better final hair design.

Psychology Tidbit about Balance

Beauty is a strange thing. People have different opinions of beauty, ranging so significantly that while one person many find a particular person to be incredibly attractive, another can look at that person and see absolutely nothing endearing at all about the individual's looks. Both are right, though, because beauty is completely subjective.

However, there is one common theme in all of beauty, and that is found in symmetry. Symmetrical faces are always considered more beautiful than asymmetrical faces, regardless of race, color, style, or other factors.

This relates directly to balance. If the hair is unbalanced on the person's face, even if that is due to their asymmetrical face shape, the hair will not be attractive. By achieving balance in hair, you are instantly making the person more attractive simply by increasing their own natural symmetry. That is one of the main reasons that balance becomes such an important part of hairstyling.

Another Part of Balance

In addition, balance is more than simply whether or not the hair is equal on all sides. Balance also has to do with eye points, which relates directly to the way that the hair is colored.

Think about the shading of a landscape painting. The artist of the painting wants you to notice something in the painting, possibly the lake or river or mountains. To get you to look in the right direction, they shade the painting in such a way that your eyes follow the natural process from darker to lighter.

It was mentioned earlier how you should want to color and style hair the way you want other people looking at it. A painter does the same thing, designing a painting so your eyes follow in a natural progression. If the painter did not add this to their work, then the eyes would look every which way, and the painter may as well have turned the painting upside down, because the way the eyes are looking at the painting is irrelevant to its content.

The same thing goes with hair. By applying the idea of form and balance to hair, you are meant to color and style in such a way that the individual's eyes look upon the hair exactly as it was meant to be looked at. Perhaps you do not want to draw too much attention to the top of the head, so you color it darker so that the first thing others see is the lighter tips of the hair.

That is an example of how balance does not just have to do with symmetry; it also has to do with where the individual keeps his or her eyes on your masterpiece.

Chapter 5 REVIEW QUESTIONS

1. *What are the two different kinds of balance points with hair?*

2. *What makes symmetry so important in hair design?*

Chapter 5 QUIZ

Fill in the blank:

1. The two types of balance points are _____ and _____.

2. By achieving _____ in hair, you make the person more attractive simply by increasing their natural symmetry.

3. Although learning to pay attention to every aspect of hairstyling — from the moment the client walks in the door until the moment they leave — can be stressful, eventually you will learn to do every part with such ease and efficiency that you will rarely ever make a mistake, resulting in far less stress in the future. True or False?

Answers:

1. *Odd and even*

2. *Balance*

3. *True*

6

PERMANENT *waves*

LEARNING OBJECTIVES

When reading this chapter, pay close attention to the following points:

- *What types of lotions are available*

- *The primary ingredient in lotions*

- *Effects of tension on hair*

- *Wet hair and wrapping the perm*

- *"Walking the rod"*

- *The many different types of hair*

- *Same-day perming and coloring*

- *The warp zone*

- *The dangers of too much chemicals*

- *How water neutralizes*

- *The beauty of the permanent wave*

- *How to create a permanent wave*

- *How to explore waving creativity*

Introduction

It is time to discuss permanent waving. Permanent waving, known affectionately as the "perm," is one of the most beautiful, elegant, and difficult-to-create hair designs. People get perms for different reasons — some people just like curly hair, some enjoy the elegance of it, and still others simply get a kick out of how artistic the flow of each curl is.

In fact, these waves are the pinnacle of hair design. Every single curl is an amalgamation of talent, beauty, and artistry. Every wave has a unique flavor, with the hair curving at a different, almost imperceptible angle at every turn, which changes how the hair looks aesthetically.

When I got into the idea of permanent waving, I did so because the style and beauty of these curls and designs is so unique and so magnificent that even when I do the same hairstyle over and over again, it always seems like I am doing something new.

Everything about permanent waves is a unique process that affects the perfection of each wave. Every bond that breaks down affects the curl, every bit of moisture affects its flow — even the way your fingers touch the hair can affect the way the overall perm looks once it is completed.

Permanent waves are pure hair art, and everything you learn and everything you see in life affects the way you design each individual's hair. From the curves of the skyline to the waves of the cloud, each perm is a reflection of the artist on his or her medium and of the experiences of each hairstylist reflected in his or her work.

And so it is with that in mind I decided to focus my energy on the subject. I have been creating permanent waves for years, and I continue to enjoy the artistry of it. But I am also constantly learning, and even though I may be an expert at creating the perfect perm, I will never stop continuing to learn more about permanent waves and how to correctly design the hair in order to create the perfect hairstyle.

An Introduction to Lotions

One of the things you must know before you begin any type of permanent waving is what permanent waving lotions are available and which ones to apply. There are two primary types of waving lotions:

- Acids

- Alkaline

Both of these lotion types are made with the ingredient "thioglycolate." Thioglycolate is known for its ability to break up polypeptide bonds after you apply tension. You want to ensure that whatever product you choose has this ingredient because it is incredibly helpful for making sure the right amount of swelling occurs for proper elasticity.

Getting to know lotions is one of the first steps toward understanding how to start the permanent waving process.

Introduction to Wrapping Tension

The tension of hair makes a huge difference when you begin the wrapping process. To wrap correctly, you want to ensure that you fully understand the tension of hair and how hair tension affects the style. For example, the wetter the hair is, the more elasticity it has, and the more tension it can get — which, while easy to manipulate, can cause the hair to have too much tension at the time of styling. All of these factors make understanding tension a very important part of perm knowledge.

The pictures on the following pages illustrate wrapping with double-end papers for proper tension.

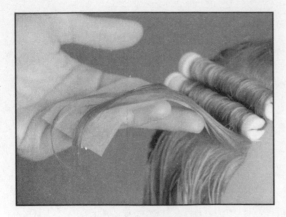

bottom paper

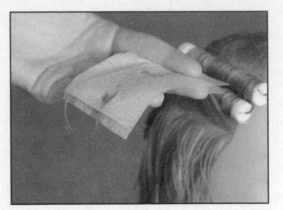

top paper

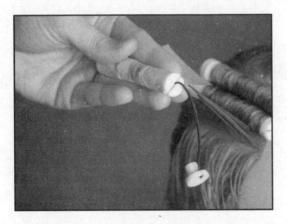

wrapping with left hand as guide and
right hand rolling rod

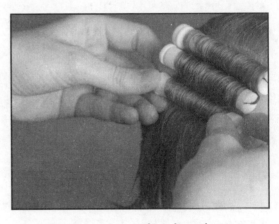

secure rod to head

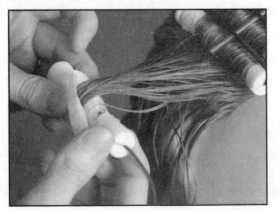

sloppy wrap with one paper

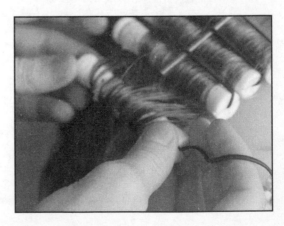

loose tension

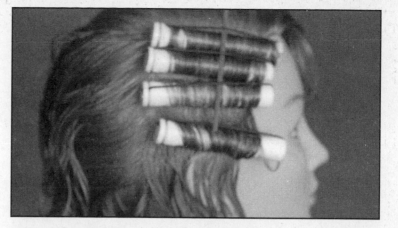

secure sloppy wrap

TENSION AND PERMING

With perming, tension works in the following manner: When you start the perm rod in your hair using your end paper, the hair should have very little tension at the ends. As you continue to wrap the rod down the hair, however, the tension increases because you will have a grip on the hair. The more

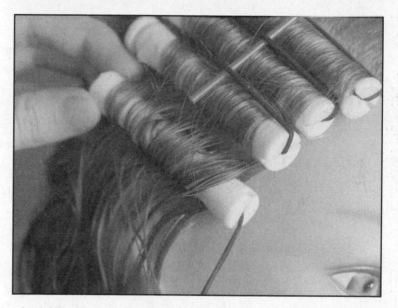

the difference between the loose tension and sloppy wrap and a secure sloppy wrap

you pull with the rod, the more the tension is going to increase. Since the tension is going to increase naturally, you rarely need to try to apply extra tension yourself. Rather, let the natural increase from the perm rod create the tension for you.

TIPS TO TENSION

Every hair artist has their own preferred method of applying tension to the hair. As long as you are not damaging the style, using the amount of tension you are most comfortable with is very important for ensuring you are able to complete the style. However, here are my own personal tips about the best way that I have seen to apply tension to hair:

COSMO'S TIPS TO TENSION

1. **Try to keep the hair evenly wet** — *This will ensure there is no extra tension being applied to some hair and not others, due to the difference in elasticity.*

2. **Try to keep the tension even around the wrap** — *Again, you do not want extra tension in some areas and not in others, because it is possible this will mess up the look.*

3. **Light tension tends to work the best** — *I have found that lighter tension makes it less likely you will damage the hair.*

4. **Try to avoid wetting the hair after the wrap is complete** — *If some hairs become wetter over time, this has the opportunity to negatively affect the tension in the hair, causing it to become more elastic or unevenly balanced, stretching the hair and ruining the tension you have already created.*

 *(**Note**: To do this, you will need the correct amount of moisture from the beginning. This involves wetting the hair a lot when you first start and slowly decreasing the amount of wetness as you start to speed up your perming abilities.)*

5. **Practice makes perfect** — *One of the best ways to understand tension is to practice it as well as thoroughly familiarize yourself with exactly how it works. Even rolling up a towel will help you understand the tension process, so practice on a towel, a shirt, or hair in order to ensure you have mastered the idea of tension and how much it increases.*

MOISTURE WITH WRAPPING

Several products on the market can help you achieve the perfect amount of moisture you are looking for with wrapping tension. Any company that manufactures a permanent wave product will likely have one available, but to ensure you pick out the right one, be sure and ask whether the product alters the strength of the permanent waving lotion or slows down processing time. Those questions are important because if the moisture affects either of those items, it can cause damage to the hair and make it more difficult to style.

HOW TO WRAP WITH TENSION

Wrapping the hair is achieved by keeping the hair evenly wet and using one hand to guide the hair while the other hand twists the perm rod. This method is preferred over "walking the rod," which involves alternating the rod between your two hands, which causes the tension to be more lopsided due to the constant changes in pressure. Using the single-hand method is the only way you can be sure you are not missing or giving incorrect tension to hair as you roll it up.

*I*ntroduction to Hair-Type Needs

The different degrees of hair thickness, color, and strength all have different effects on a hair's ability to withstand tension and perming.

FINE HAIR

Fine hairs may give the impression that you need a stronger perm to get the curl pattern you want, but in fact, looks can be deceiving. Some fine hairs are affected by softer perms, while others need extra strong perms, depending on the strength of the hair. Therefore, for fine hair, it is incredibly important to perform a cuticle test. Cuticle tests are designed to learn about the true hair type, not the appearance of the hair. Despite being fine, the cuticle may be so closed and tight that it requires a great deal of additional swelling with alkaline to break down the bonds.

In general, however, finer hair requires a smaller rod to achieve the same results as a larger rod on medium or coarse hair.

MEDIUM HAIR

Medium hair is some of the easiest hair to perm because it is not weak like finer hair, nor difficult like coarse. If you use the right rod size for the section you are using, don't rush, and properly check the hair's elasticity and porosity, then you should be able to perm medium-density hair without any problems or issues.

COARSE HAIR

Coarse hair's most clear problem is that it is hard to get smooth around the rod. Considering you are trying to maintain proper elasticity, if you find that the hair is not going evenly across the rod, you will be forced to keep trying until it is smooth (otherwise, you may be left with an awkward frizz ball). To fix this, make sure the hair is very wet so it rolls smoother, although this can be difficult because it also tends to dry more quickly. Feel free to consider a pre-wrap solution to ensure you are able to control coarse hair.

FINAL THOUGHTS ON HAIR DENSITY

It is always a good idea to perform strand tests whenever possible to understand the curling differences of fine, medium, and coarse hair. Always remember to pay attention to water weight, though, as this can also affect the curling ability. If you need to, remember to use a paper towel to blot excess water off the rod.

- Don't forget about the polypeptide bonds, which should be broken only about 80 percent if you expect to create the optimum curl.

- Always watch the cuticles so they do not swell or have too many broken bonds.

- Practice. Feel the cuticles throughout each procedure (before shampooing, before the pre-wrap lotion, before applying permanent waving, or after rinsing) and continue to feel the hair. This will help you

understand exactly what you are doing to the client's hair and how easy it will be for you to perm it without damage.

Introduction to Perming and Coloring

Most people only want to go to the hairstylist once, and many people — especially those who are conducting more drastic changes to their hair — want their hair to be colored as well as permed. As the artist, this may be something you want to do as well as you help create their style. But if you are tempted (or forced) to color their hair the same day as the perm, you need to fully understand both the consequences and the method to do it correctly.

SAME-DAY COLORING

When you color the perm on the same day, the natural acids in the color break down an additional 20 percent of the bonds in the polypeptide chain. In re-growth areas, coloring those areas should even out the porosity as long as you color them first, before perming.

If the hair has no color, however, you need to perm first, as the additional 20 percent of broken bonds can poorly affect your perming ability, causing the perms to lose formation.

RETOUCHING

While it may seem on a surface level that retouching a perm is easier than creating the perm, retouching a perm can actually be equally difficult — or at least tricky for the permanent-wave novice.

The first thing you will need to do is see if you can even out the porosity, otherwise there is not going to be any way to retouch the perm. To do this, you could use:

- **A pre-wrap solution** — This will work in general, but it has the potential to affect re-growth.

- **Conditioner** — Conditioner could slow the penetration of already permed hair, but it is unlikely to slow penetration down for long.

- **Root perming** — This could work as well, as root-perming devices are conceivably able to stop ends from getting the solution on them, but the ends may need some perming as well.

All of these methods are risky, but unfortunately they are your only options. That is why it is always important to do a strand test whenever you are unsure. Not only will it prevent mistakes, but it will help save you time down the road once you begin to understand the hair of the individual more. Making a mistake is far worse than the time it takes to test the hair.

The Shampoo Bowl

Shampooing the hair is an art form in itself. You need to get deep down into the hair to remove much of the thioglycolate residue; otherwise, the hair will smell terrible, and the hairstyle may have some repercussions from those chemicals remaining in the hair. You do not want to hinder the ingredient, but at the same time, you do want it out of the hair when its job is done.

Speaking of shampooing, many people do not shampoo long enough, either due to laziness or the tiredness they feel in their arms and legs, resulting in a 5-minute rinsing turning into a 5-second rinsing as people try to rush through the process as quickly as possible with the hopes they can finish early.

I call this the "warp zone" — the place where time seems to slow, and if you do not give yourself the strength and patience to complete the proper rinsing time, you have the potential to either ruin the hair or ruin your reputation with the client, even though you have given them an amazing hairstyle. It is vital that you give yourself the strength to complete the entire process — no matter how tired you are or how much you feel you are in a hurry — because you do not want to ruin a great hairstyle or someone's happiness simply because your arms, back, and legs were tired.

But I digress. One thing to know is if you want to neutralize the hair, run it under water. This is because oxygen is a neutralizer, and water has a great deal of oxygen in it, so you are able to neutralize the hair without having to wait for the environment to hit it.

The longer you rinse the hair, the better structure it will receive, and the client will know that you have given it your best effort. I have been around several stylists who are amazing at giving perms but have no idea how to rinse, so the end results are subpar at best. You want to make sure you have given it the proper amount of time — five minutes at least, if you can. This will help to make sure all of the bonds are exactly as you want them. The client deserves your best effort, so do not let being tired hinder your ability to give them the full rinse they need.

DRYING THE HAIR

As for drying the hair, you will want to get all of the water out if you expect the neutralizer to work correctly but, obviously, a heated hair dryer isn't going to work. At Planet Cosmo, we like to use a paper towel or a cool dryer for about 10 to 20 minutes, depending on the length, in order to help remove much of the excess water. The exact amount of time will come from experience, but use that much time as a starting point when you look to figure out how long you should spend on the process.

WORD OF WARNING

Be very careful not to over-dry the hair. If the hair is too dry, it will be incredibly hard to apply the neutralizer. Also, if the hair is not blotted dry, then the hair on the top will dry but the rest of the hairs will remain wet, causing the hair to have excess moisture — this could ruin the neutralizing process. You need even moisture all over the hair.

Also, if the hair is weak, you are left with another issue: If you find that the hair is weak and the neutralizer is having a problem, it may be time to enter the shampoo bowl again. But at the same time, if there is excess water weight, it can pull down a style. It is also dangerous if there is still some neutralizer in the hair. All of these can pull down each curl, so when they dry, they will be imperfect.

Many people accidentally leave neutralizer in the hair, and when they pull the hair back, the curl will be ruined. More often than not, the stylist blames it on the individual's hair, asserting that they did not make a mistake. But the client blames it on the hairstylist and, eventually, you are going to lose that client, no matter how good a job you did or where the error occurred. Always make sure all of the neutralizer is out of the hair and that the moisture is even; otherwise, weak hair is going to be the first hair type to suffer from the negligence.

SHAMPOOING FINAL THOUGHTS

It is all too easy to mess up even the best created hairstyle. If you do not achieve the balance correctly, even the greatest hairstyle of all time is not going to be viewed positively by someone who does not see it as balanced on their head. With shampooing, even if you have done everything correctly, if you do not get all of the neutralizer out of the individual's hair, there is no way you are going to be able to hold their curls correctly — losing both your hairstyle and your client.

What you should take out of this is that small details seemingly unrelated to the perm itself can actually make a big difference in the overall results. The success of the style is not dependent solely on how the hair dresser managed to complete the perm; it is also dependent on how well the hairstylist did all of the little things that helped make sure the overall experience was related to the success of the hairstyle.

HOW DOES THIS RELATE TO YOUR DAILY LIFE AS A HAIRSTYLIST?

For one thing, it is meant to keep you focused. Keeping yourself focused on every aspect of hair design is vital to ensuring the final hair design is exactly as you and the client wanted it, and that no mistakes will be made that will ruin it. It ensures your mind is always on your craft, paying close attention to everything that is happening so you do not lose out on some aspect of your job by getting too comfortable.

But it also ensures that you are constantly learning. The more you pay attention to everything that you do, the more you will know when a mistake is made and how to fix it, as well as how to become more efficient in your work.

The standard hairstylist will go to the shampoo bowl and allow themselves to daydream while they rinse the hair. But the great hairstylist will go to the shampoo bowl and watch closely to see where their hands go and what their fingers are doing to make sure all of the chemicals are removed.

Because the goal is for you to become a great hairstylist and a great hair artist, the only way to do that is by paying attention to details.

And do not worry — doing your work with this kind of focus will not make your job more stressful or difficult. Though I freely admit that it may be difficult at first to get the hang of exactly how to do all of the aspects of hair design — and maybe a little bit stressful — once you have learned every aspect of hair design with such a skill that you are guaranteed to succeed, then much of the stress will leave your life as a hairstylist, as everything becomes simpler and easier.

How to Create a Permanent Wave

In order to teach you how to create the perfect perm, I have organized the material into an easy-to-read list, so you can see the exact steps in the order they are best done to create a good wave. Hopefully, this list will help you understand the standard steps you need to create a perm.

STEP 1: PREPARE THE HAIR

Before you do anything with the permanent wave, the first thing you have to do is prepare the hair. There are two ways to prepare hair. You can either:

- **Use a deep-cleansing shampoo**, designed to get deep into the roots to keep the hair as clean as possible, or

- **Use a mineral neutralizer** to help jump-start the bond-altering process

Both of these choices work as chelating agents that are designed to neutralize mineral residues that prevent your permanent wave from experiencing any unexpected errors. The best thing to do is use them both together to make sure optimum precaution has been taken, but at the very

least, be sure to use at least one of those two products in order to keep the hair neutralized.

STEP 2: PRE-WRAPPING SOLUTION

The next step is to apply a pre-wrapping solution in order to keep the hair evenly wet, so you can wrap the permanent wave with more control and keep the correct amount of tension throughout all of the hair. As we discussed earlier, it is vitally important to keep everything equal on all parts of the hair, from moisture to tension and lotions, in order to be sure you are applying the same ingredients to all of the hair so the curls can be strong and equal in length and beauty.

STEP 3: ANALYZE HAIR TEXTURE AND STRENGTH

Once you have completed the wrap, it is time to determine the texture and strength of the hair so that you can choose the best permanent wave type. This would be a good time to discuss with the client what it is they want exactly, as well as what your ideas are for their hair. Hopefully, all you have learned about the client goes into this discussion so that you can be sure you are organized, ready to get started, and able to show your own expertise. When you have determined the best course of action, remember these tips from earlier:

- **With fine hair,** people like to use a lower pH (acid wave) level, but it makes far more sense to do a cuticle test first to check the actual resistance of the hair. Remember to check the cuticle for porosity, and make a judgment from there.

- **Coarse hair** does not mean we necessarily have to go to a high pH (alkaline wave) level. It is still just as important to check the cuticle and make sure that the actions you are about to take are ideal for that individual's hairstyle. The worst thing you can do is make the assumption and be wrong, so taking the extra time to do the cuticle test is always a good idea, no matter how sure you are of the individual's hair type.

STEP 4: TEST CURL

Now that you have chosen which permanent wave you are going to do, look at a test curl. Most people want to rush the test curl or completely skip this step, but it is vitally important that you do the test curl so that you know that your final decision is the right decision, and that the actions you are about to take will work. Remember to blot-dry the perm rod with a towel before you do the strand test so you can be sure your test result does not have any extra variables affecting the final outcome.

STEP 5: PERMING

Now it is time to start the perming. If you have decided the original judgments were wrong once you did your test curl, make sure you do a test curl again if you change the type of rod or style. Every decision you make should be tested before you waste that much time on the person's hair. And remember, when unrolling your perm rod, take care to make sure you are letting the hair naturally unwind off the rod without forcing it, so the hair can take the desired shape and not be altered by the way you are handling the perm rod. The ends of the hair should have a "J" shape, and the scalp area should have the rod-sized bend off the scalp.

STEP 6: CHECK THE SHAPE

Once you have both of these areas showing the desired patterns (the "J" shape and the rod-sized bend), you are ready to rinse out the hair.

STEP 7: RINSE

Rinsing the hair with the perm rods is usually the step in which time seems to slow (referred to earlier as the "warp zone"). It can be far too easy for us to feel as though we have been rinsing hair for several minutes, when it reality it has only been one or two minutes, and it simply feels like ten. In order to make sure a good amount of time has been spent rinsing the hair, set a timer for at least five minutes. Timers don't lie, but perception lies, so if you set the timer, then you will know how much time you have actually spent on rinsing, rather than the amount of time it feels like.

STEP 8: TOWEL-DRYING THE RODS

The next step is to begin towel-drying the rods. Rather than use a towel, it is a little better to use paper towels, and remember to blot-dry rather than rub the paper towels across. Rubbing is far more likely to spread the moisture, and you are looking to completely dry all parts of the hair evenly, which blotting is much better for. After you have towel-dried, consider either applying the neutralizer or putting the client under a cool dryer for five to ten minutes to ensure most of the water has been removed from the hair. Do not use a hot hair dryer. This will damage the hair. Even a warm heat is taking a risk. Cool air will do a good enough job, and although it takes longer, it is unlikely to damage any of the hair.

STEP 9: NEUTRALIZE

Next, you need to neutralize the permanent wave solution so you can reform many of the bonds that were broken during the waving process. This is a good time for you to try to impress your client by explaining the benefit of a permanent wave neutralizer. You will gain good rapport with the client, as he or she will be able to tell that you want what is best for his or her hair. By using a silicone dehydrate, you push moisture away from the salt, sulfur, and disulfide bonds that create the effective neutralizing process and allow you to shampoo the hair before 72 hours.

STEP 10: REMOVING THE RODS AND RINSE

When taking down the rods five minutes after the neutralizing process time is over, you can do one of two things:

- You can drop the rods while the neutralizer is still in the hair.

- You can rinse the hair with the rods still in.

The benefit of dropping the rods first is that you can still apply the remaining neutralizer to the ends of the hair and scrunch the hair to ensure the ends have been saturated with the neutralizer. Otherwise, you risk not having all of the hair neutralized, which means when the hair dries, there could be some differences in neutralizer evenness.

And now you are essentially done with the perm. You may want to color and style it in your own manner, but the true perm has now been completed, and if you have done it correctly, there should be no additional issues with the hair.

A Few Techniques

Now that you know how to do the perm, let's quickly discuss a few quick techniques that will hopefully help you with the rest of your perming journey.

- **Because we know that alkaline waves swell the hair, we can use this to our advantage in the perm.** If the hair is going to swell even if we do not add tension, then we do not necessarily need the rods in order to perm the hair. Instead, we can apply solution to the hair and start to create the form with our hands or wide-toothed combs and style the curls ourselves.

- **This does create the problem of creating the test curl, but the test curl can be done by rubbing your finger across the cuticle when you first apply the solution.** This will allow you to see when the cuticle is raised, and because the alkaline wave swells the hair, you can determine how much cuticle raise you have and make your decision on when to rinse.

- **The hair should also become soft and pliable.** Neutralizing this type of perm technique is a great deal of fun when you re-comb the style into the hair (after you have towel-blotted to remove moisture). Apply moisturizer to re-comb the style (being very careful to use a hair net in order to avoid moving the hair out of the style), unless you want to comb the hair when neutralizing.

- **Don't forget to do a full five-minute rinse.**

The variations of all these techniques are endless, and you can use finger waves, pin curls, plastic rollers, or simply comb the hair in the desired directions in order to create new and exciting looks that have never been seen before.

This is where the true art of permanent waves comes in. There are so many different ways to curl using additional tools that have not been explored that anything is possible. If you can use your finger to achieve a wonderful curl, think of what else you can use to create a unique look that has never been done prior to you.

Permanent waving is an art form that has such a great amount of potential that there is no limit to the new and exciting ways it can be done.

Permanent Waves Summary

There are clearly many permanent waving styles we didn't cover. But that does not mean you should not go out and try new things in order to create new and exciting styles other people can use in the future.

Hair design is an art form, and perms are the culmination of the art form. Much like painters can paint in abstract, realism, and many other styles, so too can you use hair and create many fresh and brilliant waves that will start to set trends in the future. Clients will be happy, you will be happy, and if you constantly try to do new things, your job will never get old.

And isn't keeping your job exciting what it is all about? No one wants to get sick of their job, because they have to do it again every day. With perms, the way to keep it exciting is to try new things. Sure, there will be some customers who know exactly what they want, and trying to convince them to try a new style or form is a difficult task. But for others, those clients want to be a part of the excitement as well, and they will be willing to put their appearance in your hands to see what you can do with it.

So don't hold back. Allow your creativity to flow, and let everything you have learned to go into your permanent waving. Sure, there will be a few things you will try that may not work out, but all art goes through a trial-and-error period and, eventually, you will have the vision to help you create the perfect permanent waves.

Chapter 6 REVIEW QUESTIONS

1. How can you bring your own experiences into the permanent wave?

2. What is one way to make sure you do not accidentally rinse the hair for less time than needed?

3. What are the next two steps you can do after you drop the hair from the rods?

4. How can you do a test curl using only your finger?

5. What are the two primary lotion types?

6. What is the main ingredient of these solutions?

7. What are some of the things that can cause problems with hair tension?

8. How can we keep hair evenly wet?

9. What is "walking the rod?"

10. What are the three types of hair, and how does type affect permanent waving?

11. What is the optimum percentage of bond breakdown?

12. What happens when you do not spend enough time washing hair?

Chapter 6 QUIZ

Fill in the blank:

1. The two things you can use to prepare the hair are a _____ or _____.

2. The next step after you prepare the hair is to start the perming process. True or False?

3. Individuals with finer hair tend to need a _____ pH, though this needs to be tested via a cuticle test.

4. Because the hair is going to swell with alkaline solution even if we do not add tension, then we do not necessarily need the rods in order to perm the hair and can start using our fingers or hands instead. True or False?

5. The two types of hair lotions are _____.

6. You never want to break down more than 80 percent of the _____ bond.

7. _____ -density hair is the easiest to perm.

8. _____ tests are designed to test the strength of hair.

9. Coloring hair breaks down ____ percent of the Polypeptide bonds.

10. When hair has not been colored, _____ first.

11. Water does absolutely nothing to help neutralize the hair, but at least it gets more of the chemicals out. True or False?

Answers:

1. Deep-cleansing shampoo or mineral neutralizer

2. True

3. Higher

4. True

5. Acid and alkaline

6. Hairs

7. Medium

8. Strand

9. 20

10. Color first, then perm

11. False

Helpful Tips to Remember

Here are some tips that will help you to succeed as a successful hair artist:

• Distance equals length. Always remember to adjust accordingly.

• 45-degree angles with combs help keep out scissor lines during comb over shearing.

• Always have an idea where you are going to go with the style before you start the haircut, color and perm.

• Mark your color bowls when using more than one color.

• Don't close your shears completely around the ears.

• Always remember the strand test – never set yourself up for failure.

• The thickness of the comb will affect hair texture as you cut.

• Invest in tools, products, and toys that will both make your job easier and keep hairstyling exciting. Always maintain the "MFE" (Money, Fun, and Excitement).

• You are the employee of every client. Work hard for them as you would any employer.

• When in doubt, sit back and rethink your plan. Talk to your client and all ways try to play with the hair before you wash and prepare for your service.

• Consultations are the most important thing you can do for yourself and your client. This is the experience the client deserves every time.

• Don't cut below the bend point unless you want hair to stand up.

• Know where the bend point is at all times and especially when using more advanced techniques.

CONCLUSION

REVIEW OBJECTIVES

In this chapter, we will review the following important topics:

- *Creativity and form*

- *Perception*

- *Goals*

- *Clients*

- *Hair design tips*

- *Shampooing*

- *Permanent waves*

\mathcal{R}eview Points

So our journey is coming to an end, and it is time to recap all that we have discussed in the past six chapters.

CREATIVITY AND FORM

To start, we discussed how important it is to nourish your own creativity. You, as a hair artist, have a gift. You see hair and all its potential, all of its strengths and weaknesses, and all that you can do with it. You see hair and understand how something as simple as a dash of color or a single twist on the hair near the ear can turn an average individual into someone who can wow a crowd and create a positive impression wherever they go. You, as their hair artist, can truly change their life.

We talked about the idea of form. The way the hair is shaped and styled can be inspired by all we have seen around us, from the patterns on the leaf, to the sunrise, to whatever else you may come across in your travels. And we know that every hairstyle, no matter its purpose or its origin, needs to have some sort of shape to be effective. In addition, we mentioned details like color and accents, and how you can use them to your advantage to give the hair the same type of form as one would a painting — where the goal of the hair, like the goal of the painting, is to view the hair at the angle it was meant to be viewed. Just as you wouldn't hang a painting upside down, you do not want the hair to be seen from the wrong direction.

PERCEPTION

In Chapter 2, it was time to talk more about perception. Many things we happen upon are altered by perception, just as the way to create a fantastic hairstyle is based on our ability to perceive in others.

For our own perception, we see that the more we know and the more we can visualize, the more we can learn about hair and what to do with it. We see that the greater amount of time we spend learning will be reflected in the result — even if we are not learning about hair. Going outside and people-watching is a method of learning that few people take part in these days but that can be incredibly beneficial to both your life and your life as a hair

artist. And if you have time to go out and visit the planet, taking trips and vacations and learning about the world around you, you are guaranteed to find yourself understanding more — about yourself and others.

It was also mentioned how important it is to truly perceive and understand the client. Unlike a painting, where the canvas has no choice what is painted on it, you need to strike a delicate balance between what you feel should be done to the individual's hair and what you are actually allowed to do to it. There are a lot of limitations put on the hairstylist, but at the same time, by understanding the clients whom you see, you will gain a deeper understanding of their wants and needs, and you will be able to help achieve the perfect hairstyle to match their personality.

We also talked about the importance of controlling your emotions and focusing on your craft, as well as continuing constant learning in order to better yourself and your work. Both of these are invaluable to the true hairstylist and should be practiced daily.

But most importantly, we discussed how hair design is one of the only things in this world that truly has an impact on people's lives. The way people style their hair reflects their confidence, abilities, and how other people treat them. Hair helps people make friends, build business contacts, even find a mate. As a hairstylist, while your work and artistry may be temporary (because hair will grow back), the life-altering changes these hairstyles make can be permanent, and although it may be under-appreciated at times, your art is one of the few things that actually makes a difference in people.

GOALS

Then we began to speak about goals. Goals are what keep us interested in our work and what we have the potential to achieve. Goals are what allow us to grow not only as artists, but as people and professionals, inspiring our work and helping us reach the place we wish to be in as we grow older.

Goal making is never an exact science, and although many will be tempted to set lofty goals for themselves they believe they will always want to pursue, goals are like walking through trees in the forest — if you look behind you, you may not see the tree you walked past again, and you may find that it does not matter.

Be advised, however, that it is still more important for you to continue to learn about products than to take the advice that is in this book on product choices. While we may believe a certain product or style is better than others, it is going to be your own personal experience that teaches you what the best products are, how to use them correctly, and what steps to take to ensure you are reaching your ultimate goal. How comfortable you are with a product and how well you know about the hair choices available is going to make a bigger difference than any piece of advice ever will, so continue to practice and you are guaranteed to improve as a person and as an artist as a result.

CLIENTS

None of this would be possible, however, if it were not for the clients. The clients are the reason this work exists; they are the reason that the art can happen; and they are the reason we can do this as a career that has some serious money-making potential.

Clients are also tricky individuals. For starters, you never want to take any client for granted because even the bad clients can bring in new business. Especially when you are starting out, all clients — no matter how poorly they tip or how difficult they are to deal with — are important for expanding the rest of your business.

This is why you can never work specifically for tips instead of for the happiness of the client. Although tips are what makes the job a profitable one, if you are trying to get bigger tips, you are bound for failure; if you simply let life take its course and treat everyone like equals, regardless of how much they tip, you are sure to succeed.

This includes good clients as well. No matter how well someone tips, if you act differently toward them because they tip far better than other clients, they will be able to tell — and they will not appreciate it. If you expect to keep your clients and hope for their continued business and support, you need to trust that everything will work out over time, and that you simply must continue to improve your hairstyling ability and hone your craft.

HAIR DESIGN TIPS

We talked about a few of the tips of hair design, including balance points and the shampoo bowl. With balance, you always want the face to look symmetrical and harmonious, and the only way to do that is to gain more experience with faces and how the hair sits on them. By keeping the hair balanced, you are going to be able to achieve the most aesthetically pleasing hairstyles, making the client — and the world — happy.

SHAMPOOING

Shampooing is equally scientific. Because moisture and removing chemicals is so vital for the hair to set correctly, you will always need to make sure that you have practiced and learned how to use the rinsing and the shampoo bowl correctly, as well as how to train yourself to rinse for the full five minutes, rather than entering the warp zone and finding yourself finishing in fewer than ten seconds simply because it felt like it took forever, during a perm.

PERMANENT WAVES

Finally, we spoke about permanent waves. In addition to the step-by-step instructions about how to create permanent waves, we went over the many ways that you can try to utilize other objects and abilities to create new styles of permanent waves that are bound to create a lasting impression in the world of hair. There is no limit to what you can accomplish with both permanent waves and your own imagination, and as we spoke about back in Chapter 1, it is important you recognize that you are not just a hairstylist — you are an artist who is creating a masterpiece, like Leonardo de Vinci.

Final Thoughts

I hope this book was able to help expand your mind over the many possibilities of hair design and hairstyling, as well as permanent waving.

As I mentioned earlier, the goal of this book is not to teach you the nitty-gritty about hairstyling; you can learn how to hold a scissors in salon school, and you can learn how to blow-dry from your mother or father. The goal

here is to start you down a path toward greatness — to move you from simply a hairstylist to a hair artist, allowing the only limitation in your work to be your own imagination.

That transformation will not be easy. The way the clients demand certain things makes it difficult to picture yourself rising out of the daily routine and becoming something more. But the more you learn about yourself, about hair, and about hair artistry, the more you are going to be able to achieve something greater as time goes on.

Whether it be because you set goals or because you found yourself with a lot of clients who made it easy for you to succeed, there is so much you can achieve, and there is nothing that is going to hold you back from achieving it all. If you only chose this job for money, you could have chosen any other job instead that didn't require a specialized skill or practice. In fact, holding the Stop/Go sign for construction workers pays a great deal of money, and all you have to do is turn the sign back and forth every five minutes.

But no, you wanted something more. You chose hair design for a reason. It may not always be easy to see that reason — in fact, sometimes it may be downright difficult to even remember the reason. Or perhaps the reason seems shallow to you, something that is not rooted in any deep-seeded, meaningful analysis.

But you still chose hair design for a reason, and whatever made you come to that conclusion has led you to where you are today. So do not fret about it — enjoy it. You are a beneficial part of this planet, and your effect on the world is limitless. As long as you always continue to learn, practice, and use your imagination, the hopes for you and your future are endless.

So now it is time for you to continue to go out and make a difference in the world. Whatever goals you have chosen, whatever skills you have mastered, and whatever styles you have created are all there to ensure that you live a happy, healthy life and are able to make a significant impact on the world.

I hope you have enjoyed this short book, and even if it has not opened up new revelations, take what we have discussed here and try to apply it into your daily life. Thanks for reading and continuing your learning.

ABOUT THE *author*

\mathcal{C}osmo Easterly

is a world-renowned artist, salon owner, hairdressing pio-
neer, and artistic director for ThermaFuse. Easterly opened
his salon, Planet Cosmo, in Ocala, Florida, in 1983.

With over 30 years of success in the professional beauty
industry, Cosmo has excelled in multiple areas. He's trav-
eled the world as a platform artist; developed original and
award-winning techniques inspired by the world of fine
art and sculpture; shared his expertise on "Good Morning
America" and "The Today Show;" won awards for his photo
and editorial work; runs an advanced training center; and
owns a franchise of successful salons.

Cosmo was born 1957 in Naples, Florida. He began licensed
hairdressing at age 19. He worked at J-Mar E Styling Salon

in Naples for about a year with mentors Judy Black and Jim, learning how to style hair. This experience led to the writing of his first book *How to Create the Perfect Cut, Shape, Color, and Perm for Any Hair Type: Secrets and Techniques from a Master Hair Stylist.*

After nine years of writing and preparing, Cosmo is proud of his instructional book, *How to Create the Perfect Cut, Shape, Color, and Perm for Any Hair Type*. A teacher to many, he thinks that the mentoring process has been a great experience, but that it has also taken a toll on his energy. With this book, he feels that he will be able to mentor students without the personal attachment that it usually takes. He believes that putting his techniques in writing is definitely the next step in his professional life, and that the sharing of thoughts and ideas will no doubt benefit future students and even his own daughter, Lauren Easterly, who has also ventured into the field of hairdressing.

Regarding his son, Chad Easterly, Cosmo says, "My son is a great music-maker of all kinds, and he inspires people to be great. As the two of them get older, they have paths that will no doubt take them in many different directions and affect people in a positive way."

As time goes by, Cosmo reflects back to see that "all things I give thanks for are the things that are of God, and the rest has not affected my life. Remember that if it will not change your life in five years, then do not fret, but stay focused and complete the task."

Cosmo believes the things he offers to help you better your career — such as shears, DVDs, music he likes, and hair shows he does — are all things that make life good.

"Live well, God bless you, and thank you for visiting the planet."
— www.PlanetCosmo.com

REFERENCE *section*

This special reference section contains Cosmo's best hair tips, tricks, and pointers. You'll also find detailed, step-by-step instructions for various hairstyles. Look for details on:

- *Coloring Techniques*

- *Cutting Techniques*

- *Perm Techniques*

- *Visual Inspirations Classes*

- *Helpful Tips for Success*

- *Step-By-Step Hairstyles*

Coloring Techniques

RING COLOR

To create rings of color around the head, use the flat of your brush and apply color. You can paint these rings either through different sections around the head or the top section only.

Ring color can be in dark to light on a section or can be more dramatic for a funky color. This can also be used on a section of hair to create the rings along the shaft of the hair.

ARCHITECTURAL FADING

The goal of architectural fading is to create a natural appearance that fades from dark at the nape to light at the front. For example, with a natural level 5, use level 5 colors at the nape. Keep the remaining level 5 color in a "collective bowl." Mix a level 6 color in a separate bowl and then place part of the contents in the collective bowl, giving you a blend of levels 5 and 6. Next use level 6, then mix 7 and add part of the mix to the level 6. Then use level 7 and then mix level 8 and put part

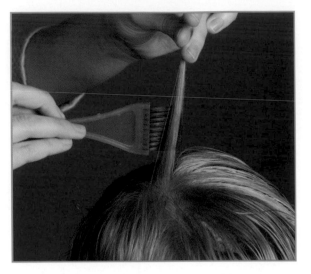

ring color applying flat of brush

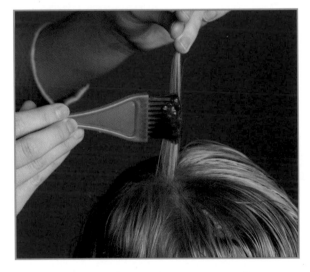

flat brush applying ring color

what ring color looks like

of the mix in level 7, then use level 8 next. This is the fading of colors from a level 5 to a level 8 or higher.

As you move closer to the front of the head, mix in colors in a similar manner, with the next level mixed in a separate bowl and then added to the collective bowl being your next level of color. This will allow a natural fading from dark to light, to the contrast of the artist's choice.

DOT COLOR

Much like its name suggests, take out a brush and apply dots to one-inch sections on the head. You will want to make sure to add depth, not just dot the top. You will also want to use enough product so the dots bleed and color spreads throughout the sections. This can be used to create movement by using two level differences in your color choice.

applying dots

CALADIUM COLOR

The Caladium Color technique is derived from the Caladium plant. To try this technique, find the focal point of the finished style and apply a circle section of color to this area. This gives you not only a starting point, but also a place to fade the remaining color application from. Next apply a "Dot Color" throughout the hair. Be sure to use two level color differences to avoid any lines of demarcation.

applying caladium

PAINTING WITH COLOR

The painting-with-color technique is designed to try to paint out about 10 to 25 percent of the client's gray hair, or to give hair a highlight effect. Many people enjoy the highlighting as a way to start the summer or blend out

lightened hair to get ready for the fall. Full, long strokes with the end of the brush will allow you to apply only to the hair that needs it. This does not have to be only for gray hair. This is very much like pin striping.

applying pin stripe

PIN STRIPING

Pin striping is like car detailing for your hair. To do this technique correctly, when applying the product be sure to apply deeply enough, so it penetrates to the scalp. You want depth to be maintained even when they shake their hair. Start at the top of the head and pin stripe the hair in a downward motion. Section and color choice depend on the original artist of each client. We have been able to create many color patterns with this technique. Before you apply to a client, apply to the mannequin, and then you will know the end results.

model with pin stripe color

TIE DYE COLOR

With the tie dye color technique, you first tie the hair in knots, similar to the way you tie dye clothing. Then apply color to different sections of the knots, using different colors for various sections. For knotting, you can use hair ties, twist ties, or anything that will hold the hair in place throughout the process.

PANEL COLOR

Take a panel of hair approximately two inches thick horizontal and place Saran™ wrap under this section. Apply color to the top of the panel. Then place another piece of Saran™ wrap on top of the colored section, and continue this pattern in an upward trend toward the top of the head. The way the panels are patterned is up to the individual artist.

OBJECT COLOR

Much like "Object Cutting" you use objects in your hair to achieve different color patterns. You can use vent brushes to apply the color, as well as combs, dust brushes or any object that you can apply color to, and then apply the color to the hair.

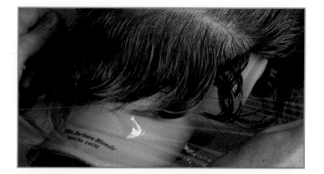

Saran™ wrap

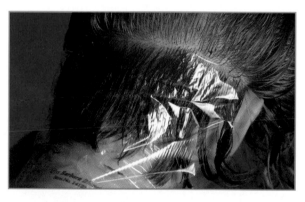

applying color on panel with the flat of the brush

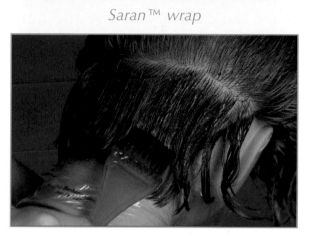

Saran™ application to panel

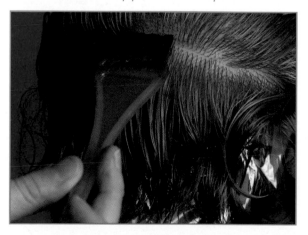

applying panel color

STENCIL COLOR

Like the name indicates, make a stencil of any desired shape or design. Apply to the head and color just as if using a regular stencil.

COLOR PASTING AND SCULPTING

Using the "Architectural Fading" method, create swirls of blended color. Since the color(s) will give the hair a pliable texture, you can sculpt the hair in any direction and overlay another color on top of it. Or you can twist the hair up and put "lightener" on the ends to create a focal point where the hair spins out when styled. Color pasting has many variations depending on how you sculpt the hair, so the artist should feel free and utilize his or her own creativity.

RE-GROWTH COLOR

The purpose of re-growth color is to darken the roots in order to give the hair a more dramatic look. Similar to "Architectural Fading" (dark to light), the only difference with the coloring is to use the existing color on the hair to create the re-growth look.

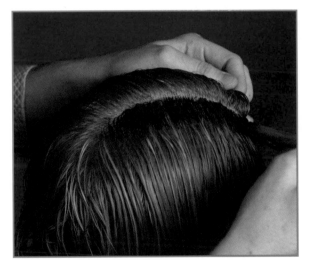

applying re-growth

SIGNATURE COLOR

Signature color is like signing your name to a piece of artwork. Signature color is used as a fun way to make a mark on your work so others can tell you were the artist. Though, of course, make sure the color blends and the letters are not too thick. This is simply the way to get you to create the looks you want. All these techniques help you understand that you can create anything you want. This is your signature.

GLOSSING

Glossing is an all-over application of permanent hair color to enhance the brilliance and luster of the hair. Glossing is more of a quick color service

that you do using a low-volume developer. The goal of this is to not alter the natural hair level, but to change or accent its natural tone. For example, if the hair is a Natural Level 5, but lacking warm tones, then you can use a yellow/orange base with a 5 to 10 volume developer (depending on the intensity desired – use a strand test).

TEASE COLOR

Tease the hair first, then apply color using the scrunch method. This will create a very natural highlight, and it works especially well with lighteners.

ACCENT COLOR

This is essentially a way to give the client an affordable color around the frame of the face. In general, when applying any hair color, it is customary to apply it all over the head or in extreme quantities. With accent color, we really apply it to just the frame of the face in order to accent the client's new hairstyle. We normally have a minimal fee of $10 to $20 for this service.

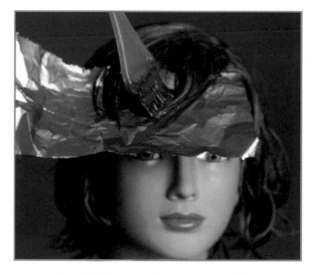

using foil to apply accent color to frame the face

SCRUNCH COLOR

Mix your choice of colors and place the color in your hands. Then, scrunch the hair with that color. This technique works especially well with any hairstyle that you scrunch dry for the finished look. By coloring in this manner, you will have naturally accented your completed hairstyle if you use two levels of color difference.

MULTI-TONE COLOR

Choose two or more compatible colors on different levels of lightness/darkness and tonal value and color using any of the standard methods. For

example, with a Natural Level 5, use a level 1 black, level 5 red, level 7 gold and level 9 gold. This allows more creativity than just a normal highlight.

TWIST COLOR

Generally used for low lighting, or to make the hair one or two levels lighter, or for corrective color work, Twist Color enables you to get more natural variation in the hair. Take some large sections, normally one inch or more, and then twist the strand of hair tightly. Allow color with a brush on the exterior side of the twisted strand. This will allow the center of the tested hair to avoid color making more of a natural color effect.

SPLATTER COLOR

There are two ways to achieve Splatter Color:

First, you can mix your color in a bowl. Then you take your brush and splatter it on the head. One of the problems with this method is that it can be a little messy and difficult to control.

Mix your color so it is creamy enough to go through an applicator bottle. Then splatter the color on the hair using the applicator bottle. Whether to splatter heavy or thin is up to the individual artist, and considering it is considered more of an "art deco" look, creativity is encouraged.

You are trying to achieve the same look with splatters as you would see on a wall or fiberglass.

COLOR FUNDAMENTALS

Color only reacts on the hair that it is applied to. Any objects or hair formations can be used for special coloring effects.

For the coloring strand tests, use 3 inches of color to one-fourth developer to know it is the color you desire. Don't take chances – always test your colors first. This is a professional approach to hair and the client.

Step- By-Step Hairstyle — Amie

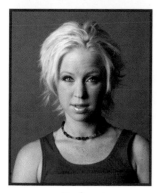

Before

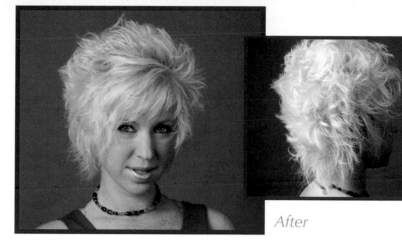

After

PRODUCTS USED:

Thermafuse volume shampoo and conditioner and Therma Care leave-in conditioner

STEP 1

Part hair from ear to ear across the rear crest of the head.

STEP 3

Taking center section of back roll hair up to create flips and cut following the head.

STEP 2

Lift hair to peak of occipital bone and pull to center of the back of the head and cut.

STEP 4

Pull side sections in to center and cut the same creating the flips. Repeat both sides.

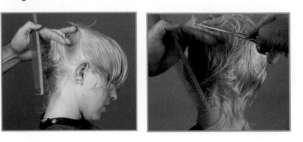

STEP 5

Take side sections parted to the parietal bone, comb hair back away from face, and cut with the same roll creating the flips. Repeat other side.

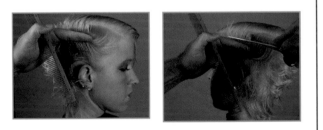

STEP 6

From the rear crest, cut short to long over the short side eye and pull rest of hair to this guide line.

STEP 7

Using the chewing technique, you will create lines in the top for more texture and movement.

Finish with thermafuse control, and fix mousse mixed and up hold hair spray to get the full texture out of this cut and style.

\mathcal{C}utting Techniques

BULK SECTION CUTTING

For Bulk Section Cutting, concentrate on finger and shear angle directional cutting. Distance equals length, so the shortest point should be the contact point of the shears. To level the hair, use a shear angle.

FREE FALL CUTTING

Hair falls its own way naturally, so do not force the hair into an unnatural position. Have the client shake his or her head to see how the hair falls. Also, have your client brush their hair to see where they start when styling from home. This is the best place to accent on their head. This is called the focal point, a place that you see first when looking at something.

DOWN RIBBING

Make sure you do not cut short hairs on top. This could result in hair standing up where you or the client wants it, but start your accent at the parietal bone — the bone on the side of your head that makes the round on your head — and work your way down in order to get volume and avoid layers. This will support the direction of your haircut.

*coming over the
parietal bone*

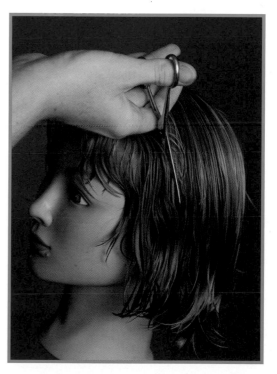

down ribbing for movement

UP RIBBING

The purpose of Up Ribbing is to accept the direction of the weight line. Once again, apply Up Ribbing in circular motions, closing the shear on the way out like Slide Cutting. This is extremely helpful in creating wisps at the ends and also movement in the longer lengths of hair.

FREE FORM RIBBING

Free Form Ribbing is for forming support to perfect the outline that has already been cut. Watch, push, and play with the hair, paying close attention to its individual shape.

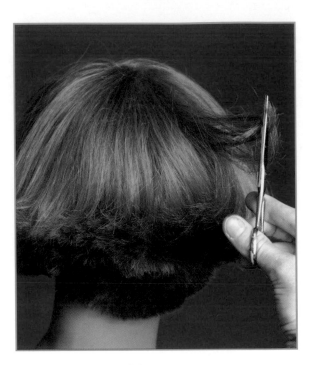

up ribbing to give more to the stack

This is not a precision cut, and the head is not a basketball. Support these forms and shapes by texturing from the scalp to the ends of the hair, working in the direction of the shear movement. If you go below the bend point of the hair you'll have pop-outs of hair that has been cut top short.

TIP AND END

Using the points of your shears to support your haircut and remove weight in specific areas, the Tip and End method is designed to be personalized and to give the hair back some of its own personality. I know it sounds funny, but hair has a feeling when you look at it, which accents the person wearing it!

CHASING

Chasing is where the hair runs away from the blades as you cut. To chase the hair, push your shears in short circular motions to create jagged lines using only the single step. This is also used in Draping where you can let the hair fall out of your fingers and then chase it.

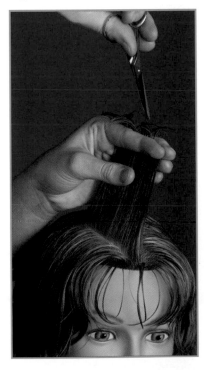

using the tip of the shear to cut into the end of the hair for texture

AIR SCULPTURE ART

The idea of air sculpture art is to treat your hair like a potter would treat his clay. Try to put the hair in motion in such a way that your client will go home and style their hair with a blow dryer using the same manner. Air sculpture art is a good way to support the hair, allowing the client some easy-to-follow steps in order to reproduce the style at home. Always remember to use a 45-degree angle with your blade so you do not damage the cuticle. This is a class at **www.PlanetCosmo.com.** Cosmo wants you to come and see how this works and is a one- or two-day class, depending on how well you know the knife.

TEASE CUTTING

Tease cutting is for adding volume in the flat spots of your haircuts. The purpose is to add support, which will form the bend points of the hair without creating any hard interior lines. This method is done just as if you were teasing the hair with a comb, again using a 45-degree angle at all times to avoid damaging the cuticle.

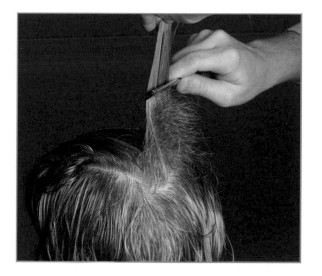

tease cutting

BUMP CROWN

For this cutting method, take circle sections of your hair – about four inches in diameter – and then comb the hair from the center, pulling it straight up. Afterward, push the hair back down to determine the precise bend point, and cut the hair. Your center section is the shortest point, making the hair easier to heighten, as though you hit someone in the head and caused a bump.

The center section should always be supported, and as a rule we use the "Tease Cutting" technique to build the bump. All ways know what the balance points are.

CHEWING

Chewing works well with fresh perms and fine hair, allowing the stylist to get a blend of bangs or sides. It doesn't cause flyaway hair or relax your new perm. The jaggedness desired affects the depth of each chew. There are many variations on this, so play and let your vision come alive to you and the client.

WAVE CUTTING

The wave-cutting technique enables you to achieve waves that go off of the hairline when styling. To start, comb the hair back as if you were combing a finger wave into the hair and cut the wave using a circular motion with a Cosmo Knife. This will create a teasing affect, and only a little is needed at a time in order to support the waves.

DE-WAVE CUTTING

Breaking waves can be difficult at times, so de-waving is a common method used to solve the problem. First, use the "Bondo" formula and rearrange the wave. Next, cut the wave as you would any solid structure – weakening it by cutting out smaller pieces one at a time. Using the Cosmo Knife, cut against the wave pattern in short strokes and be careful not to make stronger hair, which would make the wave more dominant. Try to go against the wave pattern to allow it to lay down. The bend point is very important.

DIRECTIONAL RAZORING

Directional Razoring is designed to put support hairs on the exposed sides of the hair. Normally when we support the hair we do so internally and it cannot be seen. So using the Cosmo Knife over a comb, create circular motions and sculpt the hair where you want it to go. Remember that the teeth space in your comb will also help create texture.

GEOMETRIC PATTERNS

This technique is a great way to create a vision with your cut, because geometric patterns are clean and follow the perimeter line. One way to do this is to bob the hair with geometric partings by working in one-half-inch sections starting at the nape of the neck and following the head shape. Cover each section with another tension and give your rounds on the bottom, then part, clean, and use one-half-inch sections again. Finally, load the hair with product, such as mousse, cutting lotion, or texturizer, and blow dry very straight to see the lines cut.

TEAR CUTTING

When tears fall they bubble up at different points – they are never just a solid stream of liquid. By creating variations when cutting the sections, you use up the maximum amount of width in a horizontal motion, allowing some extra uniqueness to the look. Planet Cosmo Salon uses this technique along with balance points to ensure the tears are not on the client.

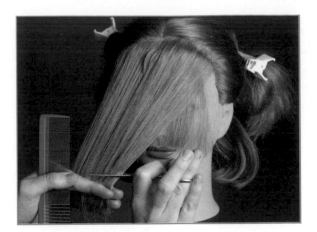

using the 1st guideline and moving 2 inches lower and creating the first tear

To support the tears, break up the hair with Tease Cutting or textured shears, but don't limit yourself to any one thing try to make it look like it feels to you the sculptor.

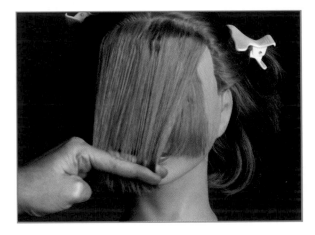

picture showing the 2-inch difference

BRUSH CUTTING

Try using a round or vent brush and roll the hair around it, in the direction you want the pattern to flow. Then take the Cosmo Knife and hit the brush between the bristles. Cut the hair only slightly – not completely or at different depths – if that is what the hair responds to.

OBJECT CUTTING

Object cutting is a brush-cutting technique that uses objects to create different looks. For example, rather than using the brush, apply the technique to pine cones, perm rods, combs, or rollers, in order to create a more unique style. If you can think it, you can apply the effort to figure out what it will take to make it happen. I always told the kids that you do what is important to you.

HAIR LINE CARVING

Since strong growth patterns like cowlicks are difficult to remove and style, comb the hair as it falls and take one-half-inch sections away, cutting against the hairline and following its pattern. Or, to make a new hairline, shave the unwanted hairline away. This is a great way to add new shapes that frame the face.

DIAGONAL CUTTING

Diagonal cutting is related to geometric cutting. And it is used on hairlines with gravity by pulling the hair down at a chosen angle and adding one- or two-inch sections for additional movement. This is great for men's hair as you can control the hair above the ear and at the temple as a triangle section. This gives more of a streamline effect to the sides.

FINGER CUTTING

First, prepare the hair by using a cutting lotion or whatever you prefer. Next, comb the hair through your fingers and put the comb down. Use your fingers to push the hair to the desired length and shape, and then cut the hair between your fingers. Remember, distance equals length, so adjust accordingly. This gives you many textures as does the comb teeth sizes. Open your hand

and feel the hair as you sculpt it, as a master of any craft plays with the medium chosen.

TEXTURE CUTTING

Use your texture shears, 5, 7, 9, 20, 44 point blender, thinners, you get the idea. Cut the perimeter shape leaving it tattered on the ends without cleaning them up with the solid blade shears. Also, you can support the style with texture shears. Remember to find the bend point so you look good not allowing the thought process to pass you by, think about what you are doing. Focus is key. Pay attention to all matters of hair, density, texture, weight, cow licks, hair lines, and crowns.

TENSION CUTTING

This is often used with geometric cutting. Use tension to help the hair remain straight and precise between your fingers while cutting to the desired length. This will help create a much stronger line.

Remember, when using a lot of tension the scalp may give a little, so be sure to adjust for this when cutting. Planet Cosmo Salon puts a lot of styling product in the hair before using this technique to easily control the hair. Sometimes it is good to use a lot of product for special effects — this is why they are made.

ROUND CUTTING

Round cutting is used when taking a vertical section and making sure you are cutting it up correctly with your shears. Start at the bottom of the section and roll the shears up to make a half moon while closing your shears slowly and arching the half moon. Continue this upwards to create an "M" effect, which will make soft weight lines. This can also be used on an angle to create finger lines on shorter hair, on a man's cut for texture or a woman's cut to make it softer, depending on your round.

X-ING

Another aspect of geometric cutting, use two diagonal sections and create an "X" pattern by cutting on diagonal section forward and adding a second diagonal section back across the forward section.

FUNDAMENTALS OF CUTTING

Don't be afraid to stretch your imagination and try new thoughts or ideas while you are cutting hair. The key is to remember your BASICs, invest in new tools, and try new products. Knowledge is power, and the more tools, products, and cutting methods you try, the more your art will benefit.

PERSONALIZE CUTTING

This is the "Big Picture" of all of the individual cutting techniques – Cut the way you wish to cut, so that you can see your vision the way you want to and do whatever it takes to get the end results in texture, movement, and versatility.

The client is an individual as we try to make them feel lifted up. Take the time to play with the hair before you start to prepare to perform a service. I cannot stress the importance of talking to your client about your thoughts and ideas. Sometimes you have to take the time to understand the difference between cutting the hair over the ear, above the ear, or over the ear — as in covering it up. There is a huge difference. Take the time to understand what the client understands and what you are thinking. I've missed the mark before, so pay attention.

Step- By-Step Hairstyle — Monica

Before

After

PRODUCTS USED:

ThermaFuse volume shampoo and condition, ThermaCare Heatsmart Serum, Uphold hairspray, and Tac to finish the style.

DETERMINE HOT SPOTS

Monica is even 0-2-4-6-8 — this is the length we cut her hair. Her facial features are soft and round. If her facial features were angular, you would cut the lengths at odd numbers 1-3-5-7.

STEP 1

Choose Thermafuse fundamentals shampoo and condition; use this time to pamper your client with a great scalp massage.

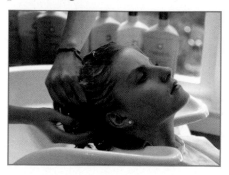

STEP 2

Use Thermacare for even moisture in hair and easy comb ability while making the hair easy to work with.

STEP 3

Use ThermaCare Heatsmart serum to prepare the hair for heat styling and cutting. This will make the client's hair extremely shimmy and reduce drying time by 30 percent while protecting the hair from heat elements.

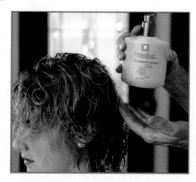

STEP 4

Monkey drying the hair removes the water. Remember to use the right hand for the left side of the head and left hand for right side of head and whip the hair back and forth while the opposite hand holds the dryer in a downward direction. When monkey drying, scrub the head vigorously to make the hair dry straighter.

STEP 5

Flat iron the hair, using Uphold hair spray to create the panels. If you use Uphold spray, the panels will maintain their shape and be firm to give you control over each section.

When flat ironing, you want to think about the direction of each section and were it is going to end up. This is a set — on-base / off-base — and scalp direction needs to be considered.

Each section will be about 2 inches in width and the thicker the hair, the thinner the section and vice versa. The average section will be about 1 inch in depth.

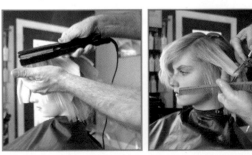

STEP 6

Cut shape into ends of each panel and make sure you are using the hot spots to get the right length; even or odd.

STEP 7

Continue to create panels all over the head. Remember — this is a flat-iron set, so keep in mind what the end result will be. I have found it best to cut the section after you have flat ironed it, then leave it in its firm-panel state. You can color these pieces in a variety of ways. Always practice on a mannequin to see the exact end result.

Finish styling the hair with any of the three Thermafuse sprays.

Perm Techniques

SCRUNCH PERM

With the Scrunch Perm, there are no perm rods. The purpose of this perm is to add texture to the hair, not curls.

Over a shampoo bowl, apply solution and scrunch the hair as you would if you were drying it. Do a finger test to determine when the cuticle is raised. No neutralizing is necessary unless you feel it's needed. Shampooing is recommended for this quick and simple perm.

PERM CUTTING

Perm cutting involves applying a permanent wave solution and cutting the hair. This technique is similar to the scrunch perm but it gives the hair a straightening affect. Be careful not to raise the cuticle too much.

Because of the time element, bulk section cutting is recommended, and again, only neutralize if you feel it necessary, otherwise just use shampoo.

BOB PERM

This style is meant to achieve fullness at the perimeter of the Bob line with the ends rolling under. For this technique we use large magnetic rollers and gently roll a little bit of the ends one at a time around the roller, clip, and continue. This technique is great for helping the hair fall underneath and allowing the client to achieve the classic bob with little effort.

WEAVE PERM

Weave the hair just as you would if you were doing a foiling, but instead you put a perm rod where you would normally put your foils. This technique can be used in conjunction with coloring if you'd like, because you are leaving your unrolled hair exposed.

BAG PERM

Using small plastic bags, roll the hair around each bag, replacing the perm rods. This is an effective way to give long hair a "super perm" in record time.

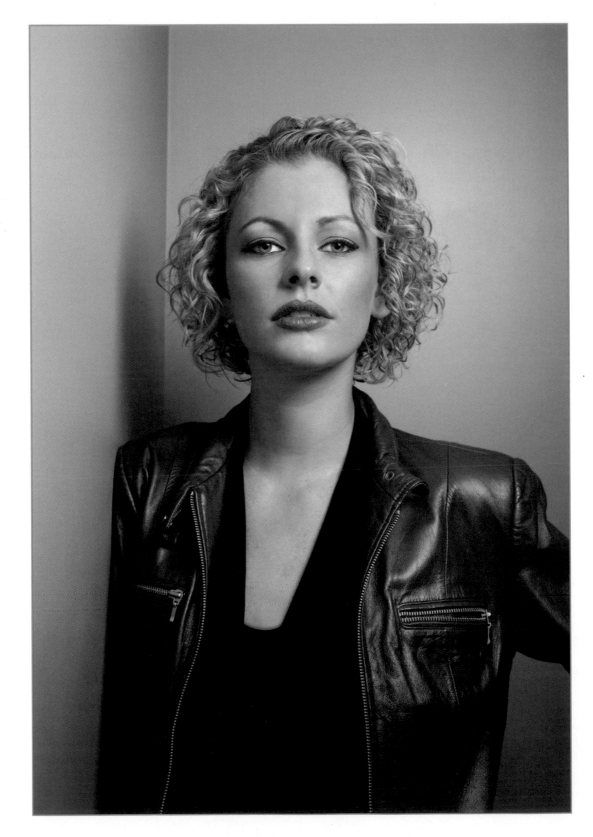

ROLLER TO ROD

Roller to Rod is best used when you are trying to achieve long, strong curls. Use magnetic rollers first to do the standard perm set process with wave lotion. Before you neutralize the perm, use a perm rod approximately two to three times smaller. Remove the magnetic rollers and replace them with perm rods with only a little tension. Finally, use a perm bag and place your client under a cool dryer for ten minutes. Neutralize the hair and style appropriately.

WAVING THE HAIR

Waving the hair is as simple as many of your first basic set techniques. When perming your new hairstyle, set the perm rods to the pattern you hope to achieve after the hair has been dried and brushed.

SKIP WAVE

The skip wave is designed to skip various sections when placing your perm rods. This technique is useful for achieving soft movement or when combining different textures. Much like the name suggests, place a roller, skip a section, and place the next roller to achieve the skip wave look.

SKEWER PERM

For this perm, take bamboo skewers or any size dowel and place them in the hair at mid shaft. Turn the skewer like a propeller on a helicopter until you've completed the wrap. Touch the ends into the twisted area at the scalp and use the skewer as a chopstick to hold the section in place for perming.

BONDO PERM

Using moisturizer that is thicker, adding it to a perm, mix equal parts in a bowl and use color brushes to apply the perm, comb the hair in different directions as you would shape a head of hair. The time for this technique should be determined with a cuticle test. After you have completed the procedure, rinse and neutralize while combing in the same direction.

RIB PERM

The Rib Perm is similar to the Weave Perm, except once you have woven the section, take your perm rod and weave it into the section. Try to leave a rib of unwrapped hair all the way down to the ends. Your ribs of hair will be left out. Continue the process as you normally would, but do not process the free ends that are hanging down off the hair.

Visual Inspirations Classes

AVAILABLE AT PLANET COSMO SALON

The best visual inspirations are:

- Your surroundings

- The person whose hair you are styling

- How the client dresses

- What the client says is very important, so listen

- Don't ask the client how they want their hair — suggest ideas

- Always remember it is your life and you need to work on what you want out of your life.

- Go back to goals and set yours so you can visualize your dreams.

- Visual inspiration is up to you and what you see.

Each unique vision that will help inspire your creative vision for your client, so you can help style the hair with your own unique personality and vision for your client.

Step-By-Step Hairstyle — Jonathan

Before

After

PRODUCTS USED:

The ThermaFuse products are volume shampoo and conditioner, Thermacare leave-in conditioner, straight cocktailed with control to give the hair a stronger molding ability. Tac to get the front moving.

The spray was nuage for finishing the trails of hair over the short textured back.

STEP 1

Determine balance points, odd or even

Determine where you want the long to be at the front. We decided to use the temple area for balance and to keep the look more classic.

The texture in the back is done with 44/20's, a thinner.

Start in the crown and work sections like a pie — out of the crown to the nape and over the ears.

STEP 2

Continue until the front. You will want to follow the head shape to the front making it form to the head.

STEP 3

44/20's are used to get the tight shape and texture by thinning and keeping the hair close to the head.

All hair has a bend point so keep and eye on this.

STEP 4

Finish the front by keeping it long and combing it back to get a classic look.

STEP 5

Style cocktail, straight and control. Monkey dry. Style with tac and nuage for finish.

Step-By-Step Hairstyle — Ariel

Before

After

PRODUCTS USED:

Thermafuse shampoo and conditioner to ensure heat smart complex and perfect hair.

STEP 1

Part hair off center and from the rear crest to the frontal crest leaving the bang area out. Cut short to long from rear to front over, directing the section over the eye.

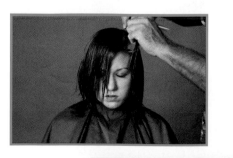

STEP 2

Continue pulling the sides of the hair to this guideline. This is a stationary guide.

STEP 3

Repeat on the other side making sure to pull to the guide line and lifting the hair straight up to ensure length.

STEP 4

Taking the back sections of the head and cutting to the guide line created by step 1, cut short to long pulling all hair to this guide line.

STEP 5

Cut your perimeter length with a slight bevel to the hair.

STEP 6

Cut your bangs and chew out to leave length, always making sure balance points are checked.

STEP 7

Finish with ThemaFuse boost for movement and texture before you monkey dry the hair.

Finish with one of the 3 Thermafuse sprays depending on your clients needs.

\mathcal{I}ndex

A

Accent color, 31

Air sculpture art, 13, 31

Architectural fading, 31

B

Bag perm, 24, 31

Balance points, 13, 16, 27, 30-31, 34, 59, 61-62, 64-65, 93

Bob perm, 23, 31

Bondo, 15, 25, 31

Brush cutting, 16, 31

Bulk section cutting, 11, 23, 31

Bump crown, 13, 31

Business goals, 31, 40

C

Caladium color, 31

Chasing, 12, 31

Chewing, 10, 14, 31

Coarse hair, 31, 74, 80

Coloring, 23, 31, 20, 41, 67, 75, 86, 11-13

Cosmo knife, 14-16, 31

Cuticle tests, 31, 73

D

Diagonal cutting, 17, 31

De-wave cutting, 15, 31

Directional razoring, 15, 31

Dot color, 31

Down ribbing, 11, 31

Drying, 21-23, 31, 77

F

Fine hair, 14, 31, 73, 80

Finger cutting, 17, 31

Form and Creativity, 31, 18

Free fall cutting, 11, 31

Free form ribbing, 12, 31

G

Geometric patterns, 15, 31

Glossing, 31

H

Hairline carving, 31

L

Lotions, 31, 67, 69, 80, 86

M

MFE, 31, 45, 88

Moisture, 21, 31, 21, 68, 72-73, 77-78, 80, 82-83, 93

Multi-tone color, 31

N

Neutralizing, 23, 31, 77, 82-83

P

Panel color, 31

Perception, 31, 29, 47, 81, 89-90

Perm cutting, 23, 31

Permanent Settings, 31, 12

Pin striping, 31

Polypeptide bonds, 31, 69, 74, 86

REFERENCE SECTION — *Cosmo's Hair-How-To Guide*

Porosity, 31, 74-75, 80

Pre-wrap solution, 31, 74-75

R

Re-growth color, 31

Retouching, 31, 75

Rib perm, 26, 31

Ring color, 31

Rinsing, 31, 74, 76, 81, 93

Root perming, 31, 76

Round cutting, 19, 31

S

Same-day coloring, 31, 75

Scrunch color, 31

Scrunch perm, 23, 31

Shampooing, 23, 31, 74, 76, 78, 89, 93

Shape and Balance, 31, 21, 23

Signature color, 31

Skewer perm, 25, 31

Skip wave, 25, 31

Splatter color, 31

Stencil color, 31

Strand test, 32, 76, 81, 88

Symmetry, 32, 59, 63-65

T

Tear cutting, 16, 32

Tease color, 32

Tease cutting, 13, 16, 32

Tension, 15, 18, 25, 32, 30, 67, 69-73, 80, 83, 85-86

Tension cutting, 18, 32

Test curl, 32, 81, 83, 85

Texture cutting, 18, 32

Thioglycolate, 32, 69, 76

Tie dye color, 32

Tip and end, 12, 32

Twist color, 32

U

Up ribbing, 12, 32

W

Walking the rod, 32, 67, 73, 85

Warp zone, 32, 67, 76, 81, 93

Wave cutting, 14, 32

Waving the perm, 32

Weave perm, 23, 26, 32

Wrapping, 32, 67, 69-70, 73

X

X-ing, 19, 32